IMAGES
of America

LAKE FOREST

ESTATES, PEOPLE, AND CULTURE

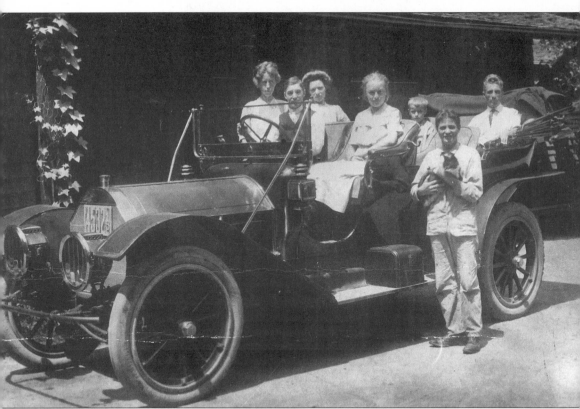

Waldron Julian, standing by the running board of Francis C. Farwell's Pierce Arrow automobile, c. 1915, later was one of 16 Lake Foresters to die in the armed forces during World War I. Family and friends pictured with him here include two identified men and two women who are known to be present. The men are (left) Waldron's older brother David Julian, the Farwells' chauffeur and a 1910 immigrant from Cornwall (England), and (far right) Joe Heibel. The women are David Julian's spouse, Ellen Frangquist Julian from Iron Mountain (Michigan), and Mrs. Heibel. (W. Julian.)

Cover Image: Grinning and gazing into the camera is George Alexander McKinlock Jr., standing near a group of female spectators at a 1907 or 1908 Onwentsia Club Horse Show, a benefit for local charities such as the Alice Home Hospital. Harvard-educated McKinlock, whose family estate was on the northeast corner of Deerpath and Waukegan Road, also died in World War I, the 1917–1918 event which ends Lake Forest's first, most dramatic estate period. (Coll.)

IMAGES
of America

LAKE FOREST

ESTATES, PEOPLE, AND CULTURE

Arthur H. Miller and Shirley M. Paddock

ARCADIA

Published by Arcadia Publishing,
an imprint of Tempus Publishing, Inc.
3047 N. Lincoln Ave., Suite 410
Chicago, IL 60657

Printed in Great Britain.

Library of Congress Catalog Card Number: 00-107882

For all general information contact Arcadia Publishing at:
Telephone 843-853-2070
Fax 843-853-0044
E-Mail sales@arcadiapublishing.com

For customer service and orders:
Toll-Free 1-888-313-2665

Visit us on the internet at http://www.arcadiapublishing.com

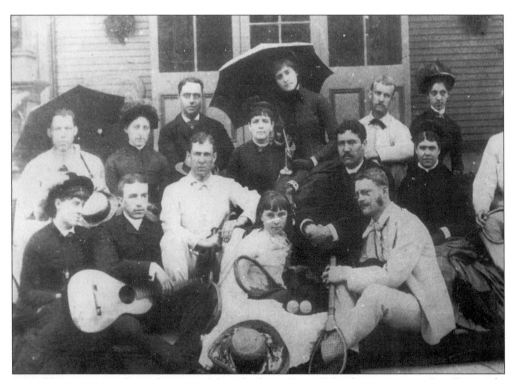

Seated here, apparently on the steps of the Charles B. Farwell Fairlawn estate on East Deerpath, is Anna Farwell (center top, under umbrella, left) with a circle of friends, including (on her left) Hobart Chatfield-Taylor, husband (or future husband) of her sister Rose. The tennis equipment and guitar suggest the ways in which the group entertained itself, probably in the 1880s or early 1890s, before the Onwentsia Club was founded in 1895. (Coll.)

CONTENTS

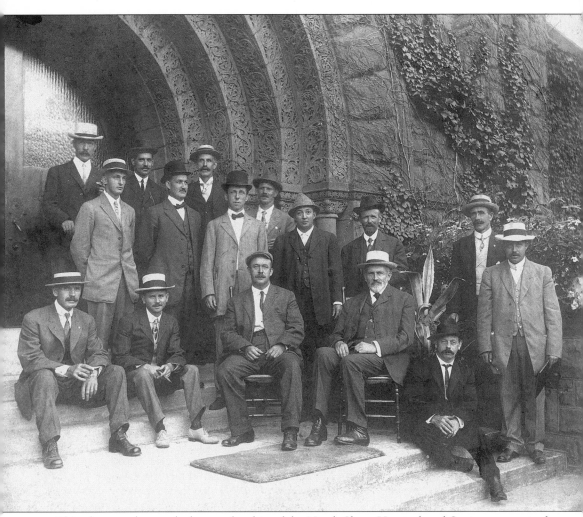

This photograph records the membership of the North Shore Horticultural Society, comprised of head gardeners on local estates, which annually held flower shows in the Durand Art Institute, the exterior of which appears here. Among those shown are (seated, left to right): Alex Binnie (Viles estate, southwest corner of Deerpath and Washington), unidentified, John Tiplady (A.B. Dick), George Kuppenhoeffer (Louis F. Swift), and unidentified; (second row) Knut Lofen, Eric Bensen (McBirney), John Newbore (McElwa, Deerpath at Lake), Elbert Parshall (Ryerson, second president of the Society), Emil Bollinger (Byron L. Smith, first president of the Society and later an independent landscape designer), and two unidentified; (back row) Robert Vipond (C.B. Farwell), two unidentified, and Henry Ellenberg. (V. Julian.)

INTRODUCTION

Lake Forest estates, especially from the early 1890s to the Depression of the 1930s, captured the regional and national imagination as a romantic, fairy-tale setting for an almost celebrity-elite, the titans of the great fortunes of the pre-income-tax era—especially before World War I, the terminal date, largely, for this book's coverage. The most notable evocation of this spirit is in characters created by F. Scott Fitzgerald in his novels, such as *The Great Gatsby*, recently termed the most significant American novel of the twentieth century—the compelling Daisy and her husband, Tom Buchanan, who came to Long Island from Lake Forest with his string of polo ponies. The iconic cultural quality of this story in this post-Reagan era is evidenced by the fall 2000 production by Chicago's Lyric Opera of *The Great Gatsby* by John Harbison and Murray Horwitz. Author Fitzgerald's three-year unrequited pre-World-War-I crush on Lake Forest's fetchingly unobtainable Ginevra King (see p. 73) has entered the national myth.

However, the myth of Lake Forest has only a billboard level of subtlety, even among locals. The evolution of this community from New England and Presbyterian simplicity to parvenu excess, followed by American-Renaissance classical achievement is little known, though the new history in 2000 of Lake Forest College by Franz Schulze, Rosemary Cowler, and Arthur Miller, *30 Miles North: A History of Lake Forest College, Its Town, and Its City of Chicago* (University of Chicago Press, 2000) should aid in improving this situation.

This book stems from two projects by the two authors, who came together from 1998 to 2000, as Shirley Paddock joined Arthur Miller, archivist at Lake Forest College, in researching the first book-length history of the College. In addition, Miller's series of articles on 40 Lake Forest estates ended when the not-for-profit local monthly, edited by Helen Yomine since 1992, *The Journal: Lake Forest* (formerly *The Lake Forest Journal*), ceased publication in 1999; he had also accumulated a few pictures in the process.

Shirley Paddock, a lifelong resident of the community with a passionate commitment to local history, had been trying for years to raise consciousness in town about the significance to Lake Forest of the estate-era town within a town and the estate workers and suppliers who enabled the proprietors and their designers to reach the level of architectural and landscape achievement for which the area is well known. This sub-group, many of its survivors and descendants disappearing from the scene, was in danger of being forgotten as a new parvenu influx bought and built over the estates. The new arrivals appeared often to lack the taste which had been drilled into the local support community children from an early age both in the local public schools and from exposure to the great places. As a part of this effort, well-known among

support community survivors, Paddock had been accumulating photographs documenting this group's and the town's past. In addition, by attending local estate sales, she acquired (saved) many estate family mementos which had been deemed redundant as the properties changed hands in the 1980s and 1990s prosperity.

Miller, especially while working with *30 Miles North*'s producer, Kim Coventry, to identify illustrations for the college history, had been encountering in archives and college office files many more photographs of the early town than that book project could absorb, even though at least 60 or 70 of the total 290 images used were of local interest. A few college-held images known but unlocated by the deadline for that history surfaced later as well—for example, a portrait of Samuel Dent (p. 32) and the 1892–93 O.C. Simonds campus plan (p. 47). Newly "discovered" in college files was the very significant, original, large-scale, mostly-identified group photo at the Holt place, 1866 (pp. 20–21).

After Paddock's volunteer research and genealogical efforts had made substantial contributions in several instances to the fast-moving *30 Miles North* effort, the two authors decided to collaborate on this project, which offered an accessible vehicle for producing and distributing some of the fruits of their respective findings with their interpretations.

Both authors are active in the Lake Forest Foundation for Historic Preservation, a quarter-century-old advocacy group working to perpetuate the distinctive local historic, architectural, and landscape character. Even though better local ordinances have been established since the 1970s, including the criteria for making changes, there is a significant gap in understanding between those who know the local character and those who are new to it. Lake Forest was and is a distinctive place, unique in the Midwest for its landscape character and heritage quality, worthy of extraordinary efforts and recognition for its protection. Loss of its legacy will equal in gravity the swallowing up of Genoa's great estates by urban development, lamented by Edith Wharton in her significant, taste-forming 1904 book, *Italian Villas and Their Gardens*. Once gone it never can be brought back.

<div style="text-align: right;">

Arthur H. Miller and Shirley M. Paddock
September 2000.

</div>

One

BEGINNINGS

NEW ENGLAND VILLAGE

Though the area originally had been settled in the 1830s by Irish-immigrant farmers, Lake Forest was a late 1850s suburban creation, an innovative version of the new railroad suburb idea. As soon as the rail line north of Chicago, parallel to the lake shore, reached Waukegan in 1855, it drew the interest of a band of elite, mostly New-England-descendant immigrants to Chicago. These immigrants were newly prosperous, thanks to the booming local economy, and also culturally distressed, due to the conflict of their church-centered, Puritan-inspired way of living with the more convivial lifestyles of Chicago's Irish and German immigrants.

The Yankees, unlike the newcomers from far-off lands, uniquely had access to eastern capital (usually from relations back home), which allowed them to take advantage of the potential from Chicago's busy transfer point. As a result, some of them were already rich. Perhaps the earliest example was Gurdon S. Hubbard (1802–1886), first arriving at Chicago in 1818 as a fur trader with the Native Americans, but later organizing the first real estate development promotion back east for the new town. Another was D.R. Holt, who would marry into Hubbard's clan as that entrepreneur's relations arrived to help in his enterprises. While in his youth, Holt also began in the fur trade at Mackinac before moving to Chicago and entering the lumber business in the 1840s. By 1850, foreign-born inhabitants already outnumbered native-born, and young families like the Holts began to look for an alternative which would allow them to benefit from the prosperity in Chicago, while preserving their church-centered, simple way of life.

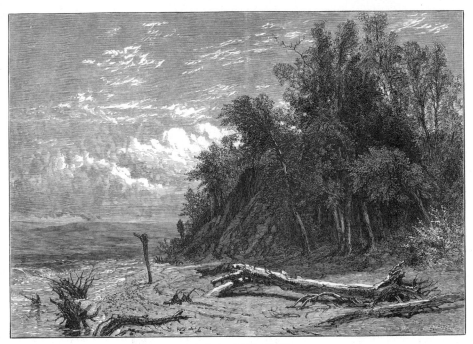

THE SHORE AT LAKE FOREST.

The irregular terrain of the shore at Lake Forest contrasts strikingly with the low, swampy setting of Chicago, 30 miles south. The bluffs at Lake Forest rise 90 feet above the lake level, the highest along Illinois' shore line, but they are punctuated by deep ravines with streams running into the lake. (*Picturesque America*, 1874; Paddock.)

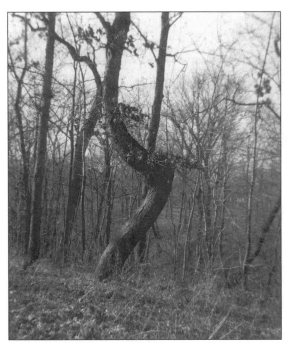

Native Americans passed along the shore and the former sand bars of the larger post-glacial lake just to the west of the shore—today Sheridan, Green Bay, Ahwahnee, Ridge, and Waukegan Roads. Bent saplings to mark the routes became trail trees, like this one near Sheridan and Rosemary Roads, photographed by local historian James R. Getz in 1955. (Getz/Coll.)

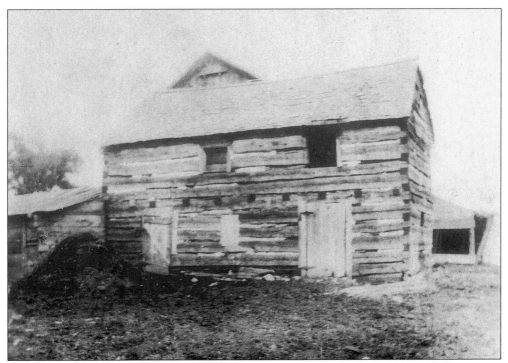

After the Native Americans' 1836 departure from the Chicago region, a settlement sprang up on the fertile prairie west of the high lake shore bluffs, which were heavily wooded and thus less attractive for quick exploitation by farming. The first settlement in what is now the southwest section of the City of Lake Forest was a mostly Irish-born farm community near present-day Waukegan and Everett Roads. This view of the early 1840s Michael Yore log cabin is from the 1918 Everett School history. (Lake County Museum.)

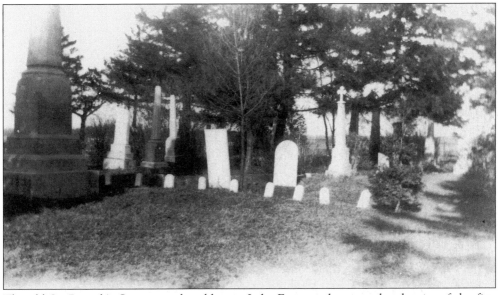

The old St. Patrick's Cemetery, the oldest in Lake Forest today, was also the site of the first church in 1842, the Catholic St. Patrick's. This too is a 1918 view. (Lake County Museum.)

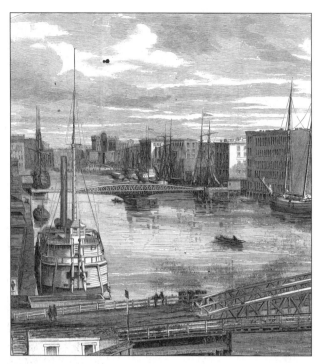

The push to build the Illinois & Michigan Canal in the 1830s fizzled out temporarily late in the decade, leading some of the Irish workmen to settle in the Lake Forest area. The canal was finally completed in 1848. The Chicago River and the canal connected Lake Michigan to the Mississippi River (the French vision almost two centuries earlier), as the caption for this April 30, 1859, *Leslie's Illustrated* engraving points out. Along the river in Chicago, also, Gurdon S. Hubbard had a pork packing house, where one (at least) of the Irish settlers near the future Lake Forest, John Connell, worked during the winters, 1836 to 1848. (Getz/Coll.)

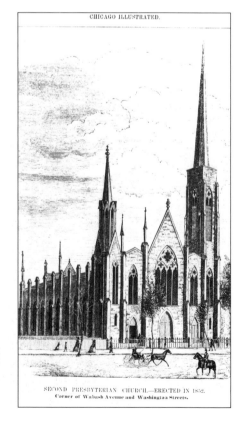

SECOND PRESBYTERIAN CHURCH.—ERECTED IN 1852.
Corner of Wabash Avenue and Washington Streets.

The drive to start a New-England-immigrant community out on the new railroad tracks north of Chicago led to the February 1856 organization of the Lake Forest Association in the Second Presbyterian Church, at Wabash and Washington Streets in the city. The church was constructed of a distinctive local spotted limestone. This view is from the first issue of *Chicago Illustrated*, in 1857. (Getz/Coll.)

The Second Presbyterian Church's founding minister was Rev. Robert W. Patterson (1814–1894), of Scotch-Irish-Tennessee stock, but a student of New Englanders Edward Beecher at Illinois College (Jacksonville) and his father, the latter-day Puritan divine Lyman Beecher (1775–1863), president of Lane Seminary at Cincinnati, where Patterson was that great teacher's favored student in the late 1830s. He is shown here as he appeared later, from the era when he was president of Lake Forest University (1875–1877) and when he dedicated the new First Presbyterian Church building in Lake Forest (1887). (Coll.)

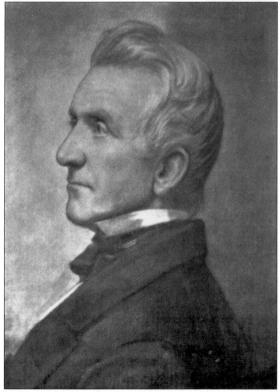

Chancery Court Judge Hiram Foote Mather (1797–1868), descendant of Richard, brother of Cotton, Mather and once a student at conservative Andover (MA) Seminary, was elected president of the Lake Forest Association's Board of Trustees, which acted quickly but quietly to buy up farm land and wood lots totaling about 2,000 acres, centered at the intersection of an old deer path to the lake (later Deerpath Road) and the railroad tracks, completed to Waukegan in 1855. (Coll./TG.)

LAKE FOREST

SCALE
30 CHAINS TO THE INCH

LAKE FOREST is one of those rare spots in which nature has laid foundations for the finest super-structures of art and taste. Many elegant mansions have been erected, which, with its literary institutions are already fulfilling the plan of the projectors, to make Lake Forest a favorite place of cultivated homes and attractive schools

Sylvester Lind (1808–1892) of Chicago stepped forward to fund the educational institution planned to be at the center and heart of the village-scaled community. An 1856 pledge of property worth $80,000 led to an 1857 charter for Lind University—a boys' preparatory academy, a collegiate program, a theological seminary, and more. A medical school was included in the plan and briefly was affiliated, housed in Lind's impressive city business block—as shown in Andreas's 1884 *History of Chicago*, v. 1. (Coll./TG.)

Judge Mather's Association Trustees invited "A[lmerin] Hotchkiss to visit" from St. Louis in August of 1856, to lay out the newly-acquired land. This pioneer landscape designer, trained on east-coast cemetery developments, created a revolutionary curvilinear street plan for a no-growth enclave for only 1,200 of the purchased acres, all of these east of the tracks and registered in Waukegan in July 1857. Hotchkiss's radical anti-urban vision recreated a rural New England village setting with central educational "parks" (today the Lake Forest College campus), the first such romantic full-scaled-town plan. This image is from an 1869 circular for Ferry Hall. (Coll.)

14

By the summer of 1858, a hotel designed by the architect (with New York's James Renwick) of the Second Presbyterian Church of Chicago, Asher Carter, had been erected on what is today Triangle Park—just east of the tracks and depot on modern Deerpath, then the only street from the plan which didn't need to be cleared of trees. This engraving is from the March 17, 1896 *Stentor*, the weekly Lake Forest University newspaper. (Coll./TG.)

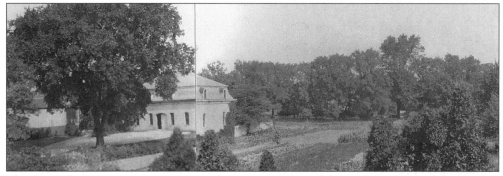

The first Lake Forest estate, northwest of the intersection of the tracks and Deerpath, was that of the Charles H. Quinlans. After a fire, the house was reconstructed in 1870 within its original walls and stands today east of Lake Forest Library. This early view of the estate shows its 1870s carriage house, later the Masonic Lodge, and today—property of the City of Lake Forest—home to the Lake Forest/Lake Bluff Historical Society, founded in 1972. (Southworth.)

Also still standing, but relocated to Illinois Road just east of Gorton Center (as pictured here) from its original location near Deerpath across from the Quinlan property, is the 1859 Italianate villa of Gilbert Rossiter. Lincoln may have visited here in April 1860, prior to his nomination in Chicago, when his name was placed before the delegates by Rossiter's brother-in-law, the influential railroad lawyer, Norman B. Judd. (Waud.)

Judd was a frequent visitor and later a resident. According to an April 2, 1897 *Lake Forester* story, when Judd served as Lincoln's ambassador to Bismarck's new Germany, 1861–65, his family group in Berlin included his spouse Adelaide's sister, Julia Rossiter, who married Baron Grunwald in 1865, an official in Czar Alexander II's household. This apparently was Lake Forest's first trans-Atlantic alliance and certainly an early one for Chicago. (Coll./TG.)

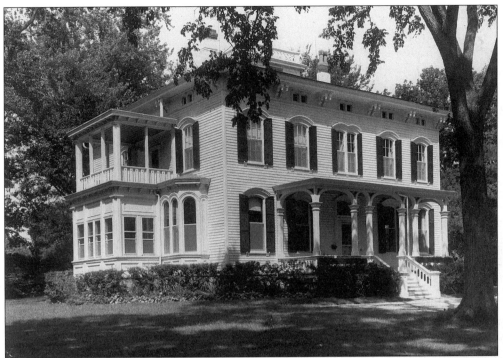

The home of D.R. Holt, The Homestead, on the northwest corner of what today are Sheridan and College Roads, was built in 1860. Holt was a lumber baron, and his commodious, fireproof-brick, Italianate villa was clad in the clapboard form of his product, perhaps not to appear disloyal to the building material which had brought him his fortune. (Coll.)

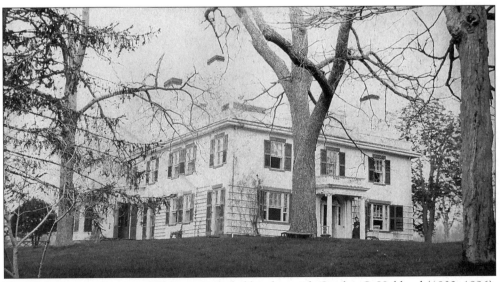

The Holts' ties to the rise of Chicago included kinship with Gurdon S. Hubbard (1802–1886), very early Chicago pioneer and booster, and his spouse. Through this link can be seen the New England inspiration for the earliest local country residences. Here is a photo, from the college archives Holt/Hubbard Collection, of the mansion-scaled home of "Grandfather Hubbard" in New Hampshire. (Coll.)

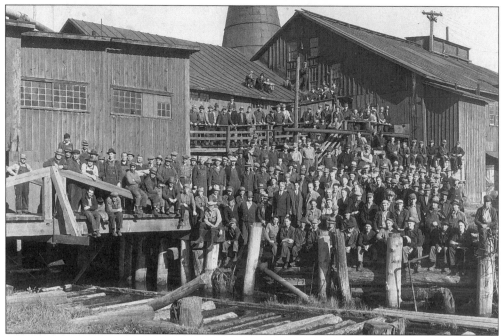

The economic muscle behind even the earliest Lake Forest estates is reflected in this photo from the Holt family collection. When the Holt family's Oconto, Wisconsin, lumber company closed during the Depression, in 1937, this photograph of mill employees captured the end of an era. A canal boat loaded with D.R. Holt's lumber in 1848—89 years earlier—had been the first such load to traverse the Illinois & Michigan Canal. (Coll.)

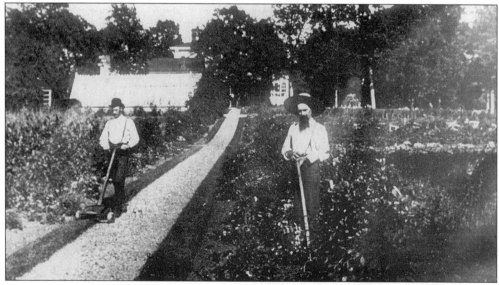

For a century, to the 1960s, the Holt garden remained in the family and stretched along the north side of what today is College Road, between Washington and Sheridan Roads. This early, east-facing image shows estate gardeners tending it, with the greenhouse nearby. The original plan, which family tradition attributed to F.L. Olmsted, was updated in the twentieth century by Winnetka (Illinois) designer Louise Hubbard and by Annette Hoyt Flanders. (Coll.)

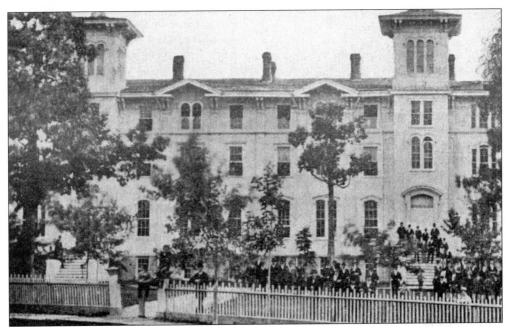

The first educational institution was Lake Forest Academy. It originated in the Triangle Park Hotel in the fall of 1858 and moved in January of 1859 to its own building designed by Carter & Drake, on the southeast corner of Deerpath and what now is Sheridan Road—today the site of the 1892 Durand Art Institute. Here, too, the Collegiate Department of Lind University briefly began operations, 1861–63, led by Rev. William C. Dickinson, a member of the poet Emily Dickinson's circle in Amherst (MA) in the early 1850s. The building was expanded from two to three stories in 1865, as it is shown here, from a 1906 *Stentor*. (Coll./TG.)

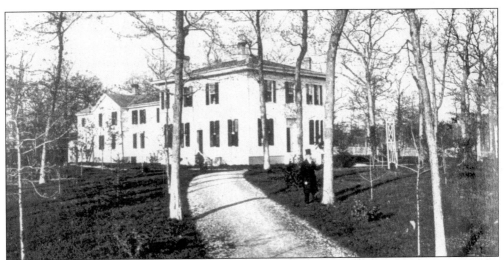

"Ready in 1859 for occupancy by Rev. Baxter Dickinson, D.D." (1795–1876) and his four daughters (Halsey, 1916) was this substantial frame building (moved and demolished) for the Dickinsons' Seminary for Young Ladies, 1859–67. Dickinson, apparently pictured here, was the drafter of an 1830s covenant of faith for the New School (anti-slavery) Presbyterians and theological educator at the Auburn (New York) and Lane Seminaries, the latter while Rev. R.W. Patterson was a student, 1837–39. William C. Dickinson was Baxter's son. (Coll./TG.)

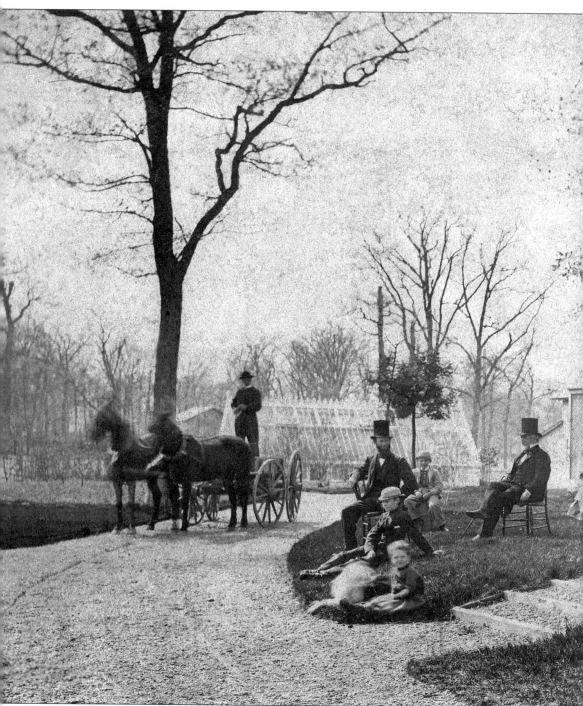

This 1866 photograph, identified by Ellen Holt (born 1870) in the *Lake Forester* of August 1, 1957, and taken on the lawn south of the D.R. Holts' Homestead, shows from left to right: a coachman, who "later went to Iowa and became a member of the legislature"; D.R. Holt; two of D.R. Holt's sons in front of him, George and Alfred; young Charles Holt; Norman B. Judd, just returned from Germany; Anna Holt (later Mrs. Arthur Wheeler); an unidentified woman;

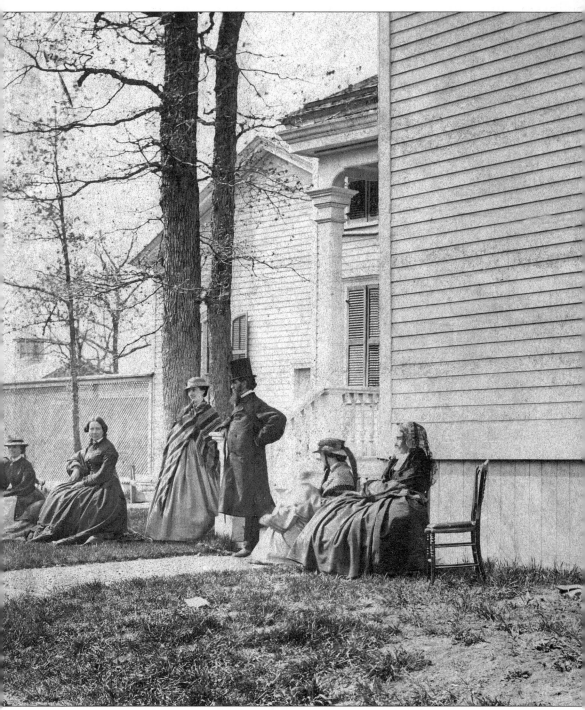

Mrs. Gurdon Hubbard (Mary Ann), Mrs. D.R. Holt's sister; Rev. William C. Dickinson's sister, perhaps Harriet Dickinson, of the Seminary for Young Ladies; Rev. William C. Dickinson himself, Baxter's son and the Presbyterian pastor who had been the College's first faculty member, 1861–63; Mrs. D.R. Holt, holding infant son Arthur; and her mother, Mrs. Ahira Hubbard. (Coll./TG.)

A typed note attached to the print of this photo in the college archives, perhaps by local historian and longtime faculty member John J. Halsey, reports that this house was sold to Mr. Edwin S. Skinner in 1869 by "Elihu Barber, who ran a boarding school for boys." This picture of the house at 400 North Washington Road, no longer existent, was taken in 1899, when the house again was sold to the Alling family. (Coll.)

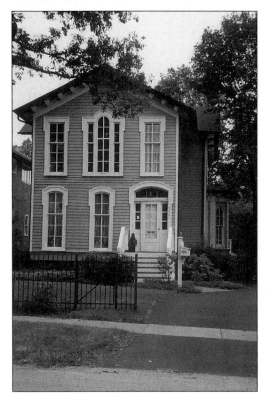

This building, now a residence located at 334 East Westminster just east of the railroad line, originally stood on the west side of Washington Road, north of Walnut (see map, p. 25). In 1860, it was Lake Forest's public school for the children of local workers. The first teacher (1860–63) was Roxana Beecher, granddaughter of Lyman (and Roxana Foote) Beecher and daughter of Rev. Beecher's most radically Abolitionist son, Rev. William Beecher. She probably taught a racially integrated class, since African Americans were in town before the Civil War. (Paddock.)

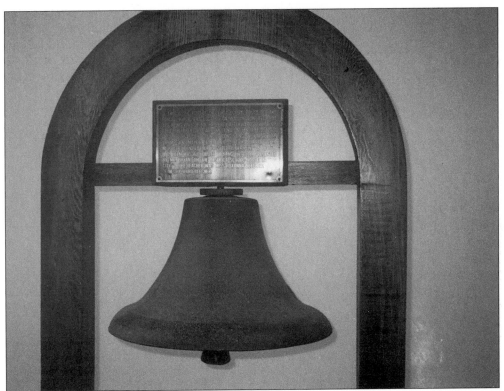

Still preserved and on display in the Lake Forest District 67 (K–8) Schools, is the bell from the original school where Roxana Beecher, niece of Harriet Beecher Stowe, taught in the early 1860s. The bell currently is displayed in the main foyer of Deerpath School. (Paddock.)

D.R. Holt had said that he wouldn't build in Lake Forest if there were any businesses east of the railroad line, the village's western boundary. However, the town's first business house had already been built in 1859, on the northeast corner of Deerpath and McKinley Roads for James H. Wright (Halsey, 1916). On the second floor, the early town trustee meetings were held. Scottish-born James Anderson, founding patriarch of a family still active in the community, kept the store from 1862 to 1867, when it was sold and rebuilt as the Samuel E. Barnum house (later the Moses L. Scudder place), today 797 North Sheridan Road. (Paddock.)

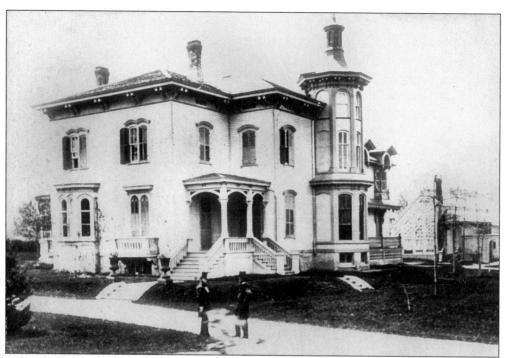

Chicago hotelier (Brevoort House) Harvey M. Thompson built an estate north of the the Holts' Homestead in 1861, the house remaining virtually unchanged until the late 1990s when it was altered by infelicitous additions. Thompson was a sophisticated gardener. (Coll.)

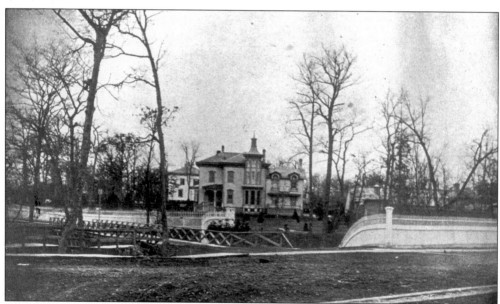

This view from Deerpath and across the ravine south to the Thompson place, with the Holt home on the left, shows the formal development of the ravine by garden enthusiast Thompson. His expertise is suggested by his own greenhouse and the presence in the Lake Forest College Library of his ten-volume set of English horticultural writer John C. Loudon's *Arboretum et Fruticetum Britannicum* (1838), with detailed plates of plants and leaves. (Coll./TG.)

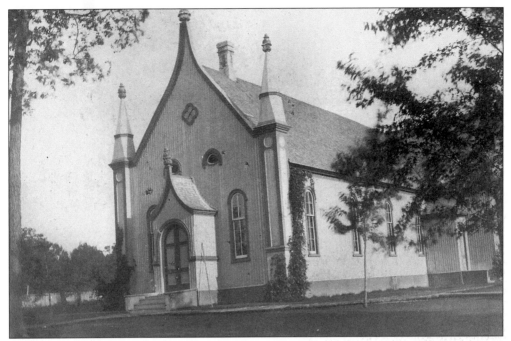

The view of the Thompson garden probably came from the grounds of the First Presbyterian Church of Lake Forest, shown here, organized in 1859, just to the north across Deerpath. This congregation met in the new academy chapel before moving in 1862 into its own Carpenter-Gothic frame building opposite the academy, on the northwest corner of today's Sheridan Road and Deerpath. Like the hotel and the academy, it probably was built from a design by Asher Carter. Later it was moved to Westminister, west of the tracks (see p. 105). (Coll.)

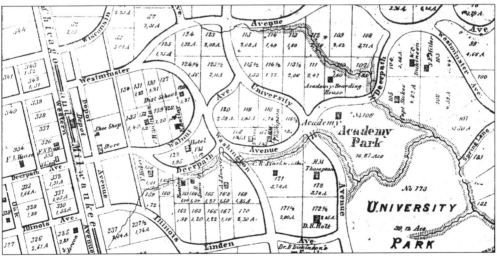

By 1861–62, the little village had taken shape as a recreation of a simple, church-centered New England town of the seventeenth to the nineteenth centuries, but already supplanted there by the rise of factories, new immigration, and farming changes. While men commuted daily to the city by train, the mothers, children, and educators lived an idyllic community, far from the diseases and alien fast pace of the bursting frontier boom town some 30 miles down the railroad line. (Getz/Coll./TG.)

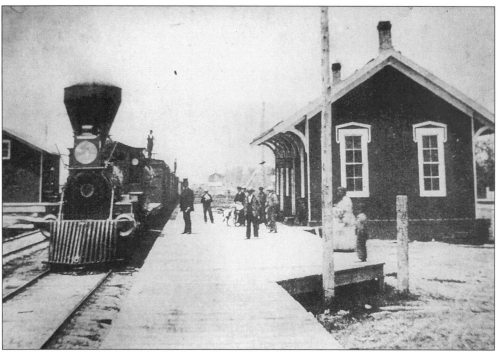

Shown here is a typical scene at the Lake Forest depot around 1860, at the western edge of the town. This was the crucial link between the Puritan-descendants' sheltered little community and its economic engine 30 miles south. (Coll.)

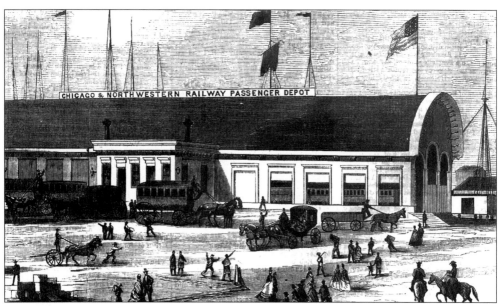

War mobilization after 1861 also swelled the transportation importance of the capital of the new northwest, Chicago. By 1863, Lake Foresters arriving in Chicago descended into a substantial passenger terminal, shown in this engraving for the April 18, 1863 issue of the *New York Illustrated News*. By that year, Lincoln had signed the 1862 Pacific Railroad and Homestead Acts, leading to rapid postwar expansion. (Coll./TG.)

Two

THE GILDED AGE

1865–1885

The end of the Civil War allowed the victorious north, most directly its enterprising citizens of the northwest, to move ahead on completing the transcontinental railroad line to the Pacific. As town after town took their places along the chain of communities on the railroad running west, each was the site of key general stores, the trade meccas for settlers and farmers all around. These general stores bought their commodities in bulk from Chicago wholesale houses—dry-goods, groceries, hardware, etc. The wholesalers bought in bulk from eastern factories and broke down shipments into bundles for the local stores. Returning from the west, too, were grain and cattle, brought to the railhead of the moment by cowboys on long drives from Texas. The cattle went to the great stockyards on the south side of Chicago to be turned into meat. Everything and everyone flowed through Chicago, the terminus of eastern rail lines going west and of the western lines going east—the hub.

The first post-Civil-War Lake Foresters were the wholesalers, controllers of vast stores of dry goods and groceries passing through Chicago. John V. Farwell was a New England descendant raised on a farm in Mt. Morris, Illinois. This future merchant prince came to Chicago in the 1840s, clerked in stores, and—a promising and ambitious young man—married his boss's daughter, Emeret Cooley. His own vision exceeded that of his elders, Chicago commercial pioneers of the 1830s, and he built a vast new warehouse in 1855, when the new rail lines were just inching beyond the city to places like Waukegan and Aurora. His sage Yankee foresight caught the image of a continental nation centered on Chicago's unique transportation advantages. A decade-and-a-half later, he was rich and the master of Lake Forest's first baronial castle.

After the venerable Rev. Baxter Dickinson fell ill and closed his prestigious Seminary for Young Ladies in 1867, Rev. William Ferry stepped forward to endow a new school for young ladies, this time a branch of the Presbyterians' University, Lake Forest University after 1865, since Lind's financial reverses had prevented his ability to fund the institution. The new school was named Ferry Hall, opening in 1869 in the lakefront park set aside in the 1857 town plan for this purpose. The architect was O.L. Wheelock, one of Chicago's pioneer builders. (Coll.)

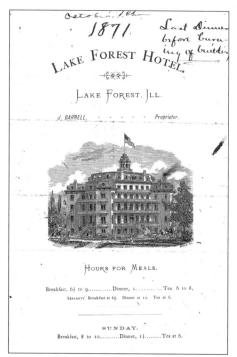

In 1869, the transcontinental railroad was completed from Chicago to the West Coast, ushering in an even more prosperous era. At this time, a new, deluxe Lake Forest Hotel was conceived and launched just south of Ferry Hall, opening for the summer of 1871. This menu which, in the words of an unknown individual, purports to be that of the last dinner served in the hotel that fall, the eve of the Chicago Fire of Sunday, October 8–Monday, October 9. The fire at first checked, but soon also proved to be just one more stimulus to the metropolis's remarkable growth. (Coll.)

28

The war and its aftermath brought a new level of prosperity and wealth, which led to a grander transatlantic idea for an estate. Dry goods wholesaler John V. Farwell's tall country house of 1869 was constructed from Portland cement, encountered by Farwell during a year in England, (1867–68)—apparently the first such poured-concrete mansion in this country. A simplified version of this first great lakefront house still stands at 888 East Deerpath Road. (Coll./TG.)

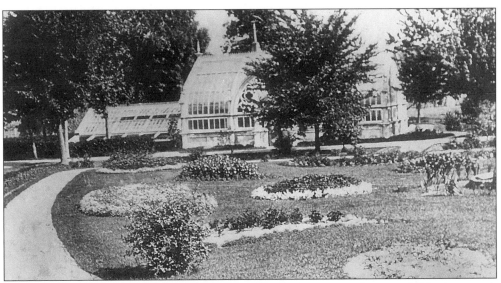

Though the architect of John V. Farwell's grand house has not yet been established, research by Harold T. Wolff located a reference to this striking greenhouse of 1870, designed by pioneer Chicago architect George T. Edbrooke. Introduced in England by landscape gardener Joseph Paxton (1801–1865), greenhouses fit the mid-nineteenth-century vogue for the discovery and cultivation of exotic plants, for which the harsh Chicago-area climate otherwise was a severely limiting factor. (Coll.)

When John V. Farwell returned from England, he brought with him builder Leonard Double, who knew the Portland cement process. Double also built himself a cement home on the northern edge of the 1857 plan, on the southwest corner of Spruce Avenue and Crab Tree Road. Monroe Winter recalls meeting old Double in the 1920s when Winter's father, the famed illustrator Milo Winter, bought the venerable place for his own young family. (Paddock.)

John V. Farwell's younger brother, Charles B. (1823–1903), a Chicago political leader in the 1850s, was his brother's business partner. He served in the U.S. House of Representatives from 1870 to 1876 and in the U.S. Senate from 1887 to 1891—a Republican, of course. He and his family began to visit Lake Forest during the summers in the early 1860s, staying with the Sylvester Linds in their simple New England-style home. Today—after substantial renovations—it is the house at 550 East Deerpath Road. (Coll./TG)

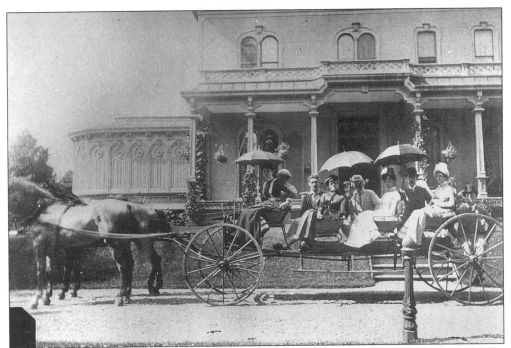

Charles B. Farwell's 1870 house and estate, Fairlawn, were built in the block just south of his brother John's, bounded by Deerpath, Lake, and Mayflower Roads and Spring Lane on the south. The house burned in 1920. The carriage party in this photo in front of Fairlawn *c.* 1885–95 appears to include (starting third from the left): Reginald De Koven, Mrs. De Koven (Anna Farwell), and Hobart Chatfield-Taylor, with Mrs. Henry Tuttle (Fannie Farwell, daughter of Emeret and John V. Farwell) at the extreme right. (Coll.)

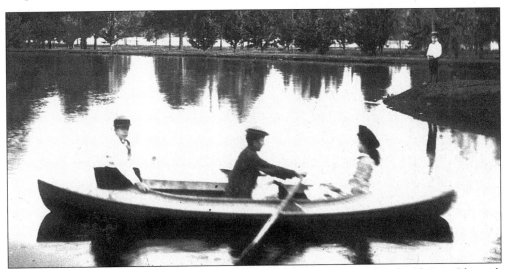

The park-like estate grounds are said (by the family) to be creations of Frederick Law Olmsted, though the Olmsted office records do not bear this out. But informal visits when the pioneer landscape designer was in Chicago in 1869 laying out Jackson Park and Riverside can't be ruled out at this time; the 1877 history of Lake County by Haines credits English-born local landscape gardener Frank Calvert with oversight of the estate. (Coll./TG.)

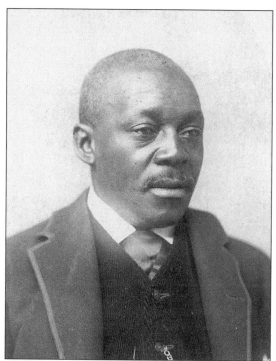

The Farwell brothers had the ideal locations, overlooking the lake shore straight east from the depot, a short buggy ride away. Escaped slave and Civil War veteran Samuel Dent (died 1890) was the local livery driver, beloved by the whole town. A memorable fictional portrait of him is at the end of an 1895 novel, *An American Peeress*, by C.B. Farwell's son-in-law, Hobart C. Chatfield-Taylor (spouse of Rose)—a jovial, self-confident, communicating, and warm-hearted local entrepreneur. (Coll.)

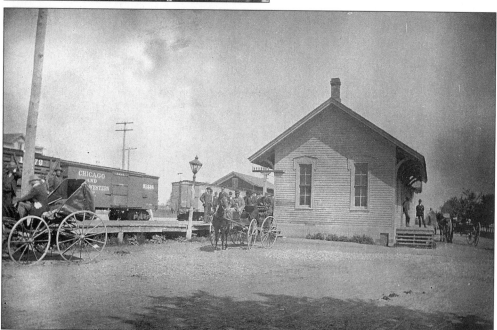

Arriving in Lake Forest after the Chicago Fire of 1871, the enterprising Dent was establishing his own livery business by the late 1870s (shown here meeting a train), with a loan from college professor John H. Hewitt. By the 1880s, he was able to erect his own building for his growing stable and hauling business. Today this site is the Country House Antiques premises, 179 East Deerpath Road. Dent was interviewed for the *University Stentor* in February 1890—months before his death. (Coll.)

According to local historian Edward Arpee (1963, 76 and 118), Dent also was a pillar of the African Methodist Episcopal Church, founded in 1866, and with its own building near Washington and Maplewood Roads, erected in 1870. This was on the northeast edge of an African-American community, which had developed east of the intersection of Sheridan and Illinois Roads as early as 1860. The congregation survived into the 1920s, the building (demolished) later being used as college faculty housing. (Coll./TG.)

Mrs. Ezra Warner was the spouse of another successful Chicago-based New England-emigrant wholesale dry goods merchant, of Sprague, Warner, & Co. This photo previously belonged to her granddaughter, Jane Warner Dick. Ezra Warner's portrait, donated in the late 1990s to the Lake Forest/Lake Bluff Historical Society by Warner's great grandson, Edison Dick Jr., now hangs in the society's museum entry hall. (Paddock.)

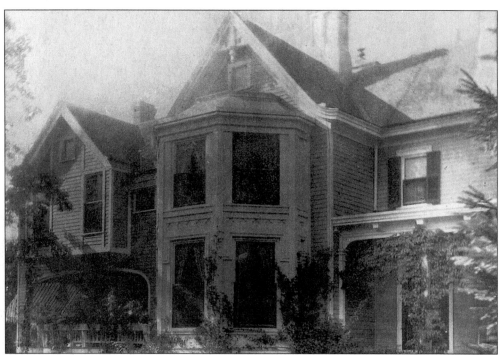

The 1873 Warner family seat in Lake Forest was called "Oakhurst," a rambling wood-frame confection which survived apparently into the 1920s. It was located north of Walnut Road between Washington and Sheridan Roads, opposite Triangle Park. The lush plants on the porch contribute to the warm period character. Reproduced here are copies of photos previously held by Jane Warner Dick, and which still belong to the family, though no longer in Lake Forest. (Dick/Coll./TG.)

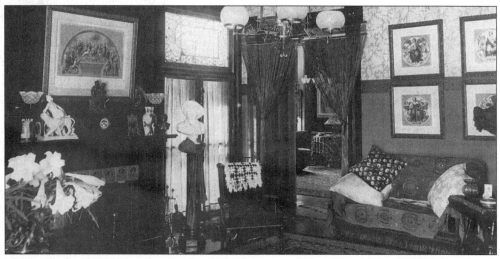

This very clear image portrays in detail the busy visual character of this Gilded Age family home. Books and pictures particularize and personalize this environment, made comfortable by relaxed country-style and aesthetic (pre-Arts-and-Crafts-Movement) furniture. The hallway, not pictured here, reflected in its woodwork the Jacobean or Eastlake style, a reaction against factory-made goods and industrial-era life. (Dick/Coll./TG.)

Especially interesting to Lake Forest residents today who are attempting to restore the oak savannah which originally covered this part of town, this photograph shows the wooded Oakhurst grounds of the late nineteenth century. Even though the house was commodious, it did not dominate its landscape. (Dick/Coll./TG.)

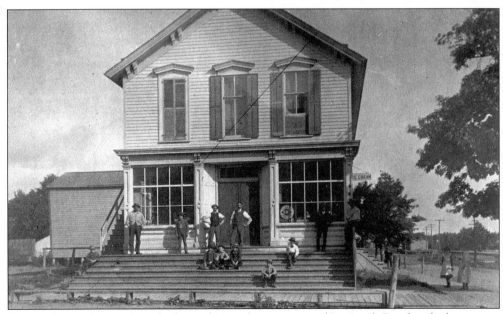

A second store in town was built on the southeast corner of Deerpath Road and what now is McKinley Road, in 1862. According to Halsey (1916, 108), in 1867 it was finally moved across the tracks to the southwest corner of Deerpath and Western Roads, where it was the enterprise of James Anderson, who moved to the northwest corner in 1870, as seen here. Holt's desire that no businesses be east of the tracks at last was fulfilled. (Coll./TG.)

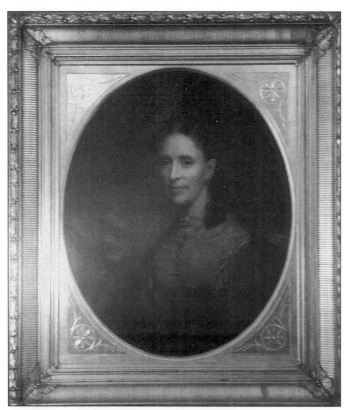

After the Civil War, patched-up politics among Presbyterians had meant there was little need for a college at Lake Forest. However, Mary Farwell (the mid-1860s portrait is by Pine, a 1950s gift of grandson Farwell Winston), herself a pioneer woman student and teacher, wanted an education for precocious daughter Anna equal to that given to men, but near home. For this she decided to revive the dormant idea of a college at Lake Forest, but a co-educational one—unusual then for private institutions. The setting was the New Hotel (p. 28), bankrupt by the mid-1870s. (Thomson/Coll.)

But an 1877 New Hotel fire led to the retirement of first president Patterson in 1878, leaving acting president John H. Hewitt to plan a new building, on the park originally earmarked for the campus, with the architect Leon C. Welch. Welch, according to documentation turned up by Chicago historic property researcher Harold T. Wolff, was a pioneer associate of Chicago architects Wheelock and Boyington and, previously in 1873, a finalist in the competition to design the post-fire city hall and courthouse in Chicago. (Coll.)

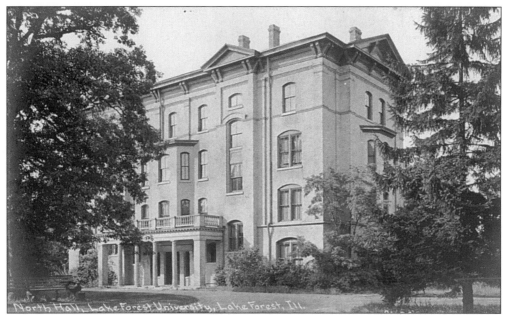

When the academy building burned in 1879, a new brick structure for the boys' school north of the university building went up in 1880, also of yellow brick. After the academy moved again to what now is the college's South Campus in 1893, this became the college's North Hall. Again the architect was Welch, with 1890s renovations by architects Frost and Grenger, as shown here. The landscape apparently is by William Gordon (died 1880), an Englishman previously at Kensington Palace gardens, then the future Queen Victoria's childhood home. (Paddock.)

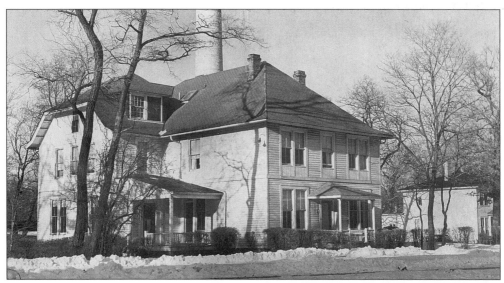

This substantial wood-frame cottage (demolished), according to university payment records, was designed by W.H. Castner, who is listed in an 1877 history of Lake County as an architect living in Lake Forest. Lasting nearly a century, this building served as the male students' dining hall until 1893, when the academy students moved to South Campus, and until 1908, when architect Howard Van Doren Shaw's Calvin Durand Commons for all male college students opened. Academia later provided space for a college infirmary and for faculty housing. (Coll.)

Crosby's Corners, the intersection of Walnut and Sheridan Roads, just north of the Presbyterian Church, was notable for the 1880s Crosby house (originally the Benedicts) on the southwest corner and for the traffic island there—shown here looking from the north about a century ago covered in flowers. These triangular-shaped islands are found all through the 1857 Almerin Hotchkiss plan for east Lake Forest, a typical feature of the English landscape gardening school. (Paddock.)

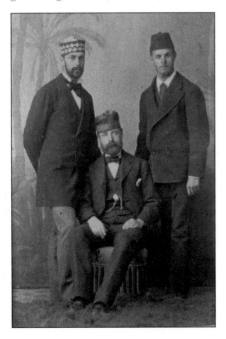

Post-Civil-War prosperity and new opportunities were symbolized by U.S. Grant's post-presidential world tour in 1879–80, an itinerary shared, or at least duplicated, that year by four sons of D.R. Holt—three pictured here posing in Cairo as the "Nile Club." Such trips became commonplace and were even satirized by Samuel L. Clemens in his *Innocents Abroad* (1869); indeed, it was this Mark Twain who gave the era its label in his novel, the *Gilded Age*, written with C.D. Warner in 1873. Exposure to Old World culture and architecture would bring fundamental changes to the outlook of the Puritan descendants. (Coll./TG.)

Three
AMERICAN
RENAISSANCE
1886–1896

Two powerful forces for change for Chicago's social elite and for Lake Forest emerged in the decade between 1886 and 1896, a series of civil disturbances in the city and introduction of new cultural forces and sophistication due to the erasing of distance by fast trains east and scheduled steamers to Europe. Chicago and Lake Forest's relative mid-century isolation evaporated as new wealth, leisure, and transportation innovations brought exposure to European traditions. These had been suppressed by the the elite conservative New-England descendants in Chicago as they adhered to the resurgent Puritan authority of the earlier nineteenth century, preached by Lyman Beecher and his follower, Robert W. Patterson.

The Chicago civil disturbances of 1871, 1877, 1886, and 1894, combined with the new travel-broadened perspective, led to many outcomes—defensive (Fort Sheridan just south of Lake Forest, virulent Nativism), socially constructive (the reform movement, including the criticism of predatory business practices, and settlement houses such as Jane Addams' Hull House), and cultural (new high-church ways, aristocratic country clubs, the Chicago Literary Renaissance, and marriages to Europeans). These outcomes transformed Chicago elite society and gave a new prominence to Lake Forest and its landed estates.

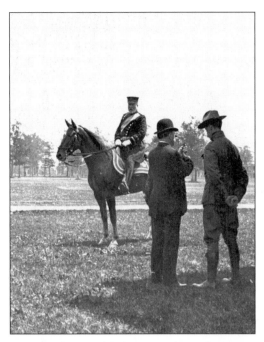

The repetition of civil disorders in post-Civil-War Chicago by the late 1880s led to the development of a military installation near the city, for a garrison prepared quickly to restore order. Fort Sheridan sprang up on Commercial-Club-donated land just south of Lake Forest. Here Illinoisan U.S. Grant's son, General Frederick Dent Grant, is pictured on horseback with the new Holabird & Roche-designed barracks in the background. The parade ground and park were laid out by O.C. Simonds. (Coll./TG.)

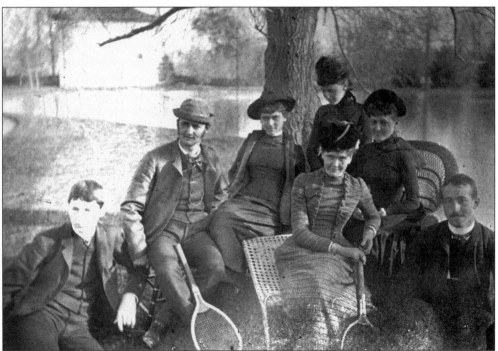

One key harbinger of change locally was the 1881 appointment as Presbyterian minister of Rev. James G.K. McClure (1848–1932), educated at Yale (Class of 1870) and at Princeton Theological Seminary—seen here on the left. The son of an Albany-based Erie Canal wholesaler who married into a leading Westerly, Rhode Island family (banking, railroads, and public service), he and Annie Dixon McClure, his spouse, had just returned from a year's wedding journey in Europe and the Holy Land. (Coll./TG.)

By 1887, the McClures had moved into a new manse, embodying the Puritan-recalling Shingle Style of Boston's innovative architect H.H. Richardson, which was designed by Henry Ives Cobb (1859–1931) and Charles Sumner Frost (1856–1931). Cobb & Frost were 1880s Protestant architectural ambassadors from Boston, who had just completed the Potter Palmers' new castle, launching the vogue for living on the north side's Lake Shore Drive and foreshadowing the doom of quaint old Prairie Avenue in Chicago. (Paddock.)

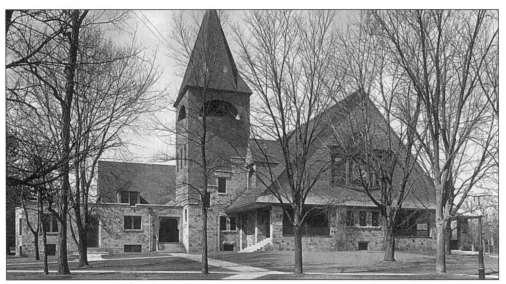

The new First Presbyterian Church of 1887, designed by Cobb & Frost and constructed by Irish-born local contractor Patrick Haley, and with it the 1892 Cobb-designed Durand Art Institute on the old academy site, under McClure's strong leadership refocused the town on the intersection of Deerpath and today's Sheridan Roads. The style again, is Shingle Style, utilizing spotted stones from the old Second Presbyterian Church (p. 12), which had burned in 1871. (Miller.)

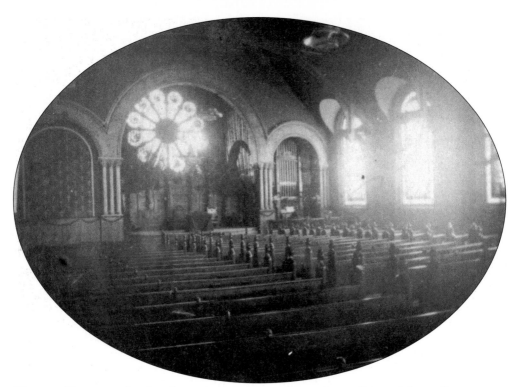

The new Norman-style church was in contrast to the stark simplicity of the earlier meeting house; the new edifice seemed to embrace a more Catholic tradition, incorporating European design heritage—anathema to the Puritans. It evoked the new humanistic cultural tendencies of the traveled Lake Forest set, a secularism so forcefully developing in the new university. Here the interior appears in an early Kodak snapshot from the scrapbook of Alexander Candee, Lake Forest Class of 1892. (Kingery.)

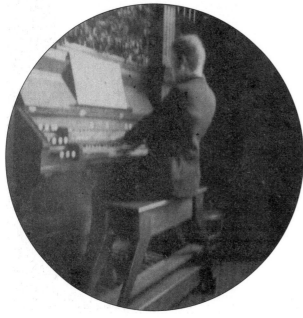

Another Candee snapshot captures fellow student William H. Humiston, Class of 1891, at the organ in the medieval interior of the new church. Humiston later would become a music scholar and assistant conductor of the New York Philharmonic under Walter Damrosch. (Kingery.)

Following their work on the church and manse, introducing a new level of style in the community, Cobb & Frost were engaged to undertake an expansion of Ferry Hall, by this time offering also an alternative single-sex college-level program for young ladies—enrolling indeed more women than the coeducational program of the University's Collegiate Department, which after 1886 was known as Lake Forest College. Taller and longer, as well as Gothic, the 1888 Ferry Hall would forecast the shape and style of Cobb-designed buildings for the new University of Chicago of the 1890s. (Cutler.)

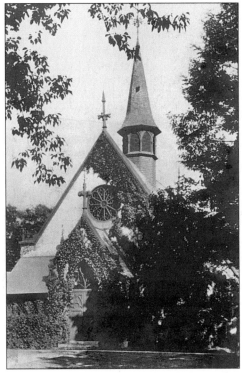

Cobb & Frost's 1888 Chapel for Ferry Hall, linked by a walkway to the expanded building, drew on a Richardsonian vocabulary of pre-Reformation design elements—tower, steeple, tall roof, elongated gables for windows, etc. It was the site for local cultural events of the era, especially before the Durand Art Institute with its auditorium, opened in 1892. Speaking there were the author George Washington Cable and Jane Addams, the founder of Hull House and of the modern settlement-house movement. Though Ferry Hall merged with Lake Forest Academy in 1973, this handsome and historic chapel still stands, now a private residence. (Cutler.)

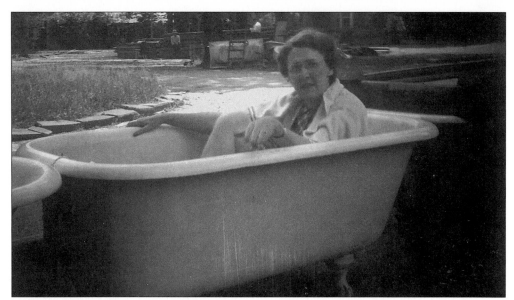

In the mid-1950s, the main Ferry Hall building of 1869 and 1888 was torn down. This playful image of the proper headmistress of the day, Frances Gibson Wallace, letting her hair down (so to speak) to pose in a salvaged bath tub, was taken by young Ferry Hall employee Shirley MacDonald Paddock, who still has a few more portable souvenirs of the stately old building. The bathtub was a prophetic image, since within a generation, single-sex genteel education for women itself would be washed up here. (Paddock.)

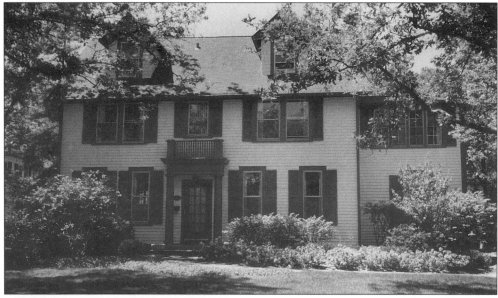

In this transitional period, the town began to expand west of the railroad line. One of the early support community neighborhoods was south of Deerpath Road, from Western Avenue west to Green Bay Road. Oakwood Avenue, two blocks south of Deerpath Road, provided the site for several 1880s and 1890s houses, including this 1883 recollection of simple Massachusetts colonial architecture at 476 Oakwood Road—the home of Lake Forest Postmistress (1887–1915) Mary McLaughlin. (Paddock.)

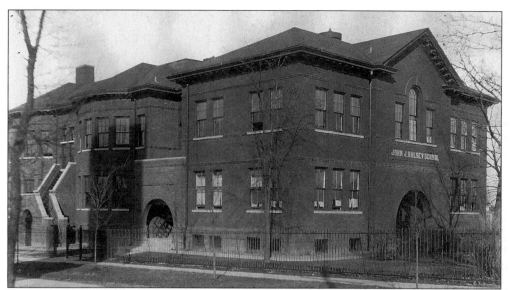

The 1888 West School was built in this expanding community at the corner of Oakwood and Deerpath Roads. When it burned and was rebuilt in 1912, it was renamed the John J. Halsey School, for the superintendent of schools elected in 1906, Lake Forest College's long-time professor of political science and sometime dean and acting president. The iron fence pictured was from the firm of Franklin P. Smith, son-in-law of Henry C. Durand and a local resident. (Paddock.)

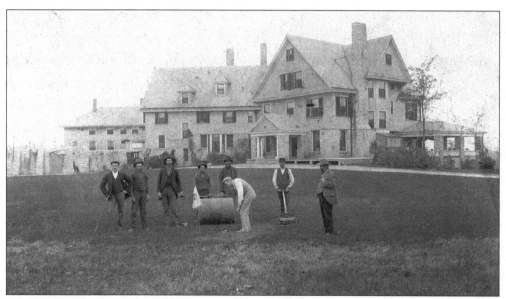

When the architect Henry Ives Cobb built his own home in Lake Forest, he chose a site on Green Bay Road looking west toward the Skokie River and the sunset, launching a new fashion. His commodious Shingle Style mansion was the largest house in town when it opened in 1893. Its grounds were designed by Frederick Law Olmsted, who was in Chicago during 1892–93 for the redesign of Jackson Park into the setting for the 1893 World's Columbian Exposition. This view apparently shows some of the gardeners in front of the house, the future of which soon would be tied to the new game of golf. (Archer/Paddock.)

45

This photo of the mid-twentieth-century police station, shows what originally was the depot, designed (or perhaps renovated) by Charles S. Frost, preceding the current 1900 Frost & Granger train station. The little wood-frame, towered pavilion reflects the Richardsonian style Frost had learned both at M.I.T. and with Peabody & Stearns in Boston. Halsey (1916, 131) reports that in 1891, the C & NW completed a new second track along its route between Lake Bluff and Chicago, making possible a new 45-minute train for Lake Forest, which reduced the effective distance of that suburb from the city. (Chicago Historical Society ICHi–24076; Richard E. Curlee, photographer.)

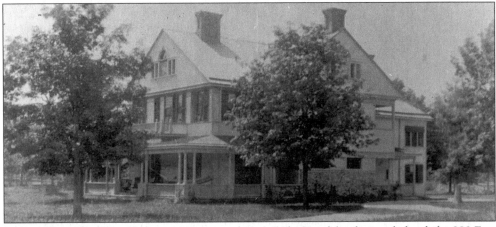

Perhaps the oldest estate house surviving so close to Lake Road (and preceded only by 888 East Deerpath, the J.V. Farwell place), is the 1892 Henry N. Tuttle place on the south side of Westminster just west of Lake Road. Mrs. Tuttle, Fannie Farwell, was a daughter of John V. Farwell, at the other end of this property. This house heralded a new level of architectural sophistication, designed by Holabird & Roche. Until the 1950s it remained in the family, later the home of the Chandlers, whose children remain active in the community. (Coll./TG.)

In 1892–93, the dynamic Rev. McClure served as acting president of Lake Forest University. As a graduate of Andover Academy, he set out to reengineer the old-fashioned Lake Forest Academy into a proper boys' prep school, on east-coast lines. He engaged O.C. Simonds to draft a plan of the university grounds. Working within Hotchkiss's 1857 outlines and naturalistic approach, Simonds sketched out an informal framework, which still today defines the Lake Forest College campus. (Coll./TG.)

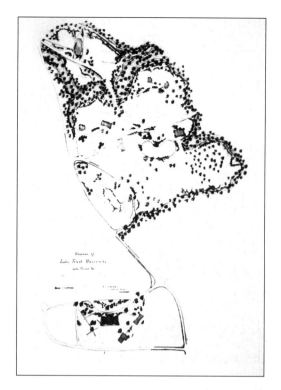

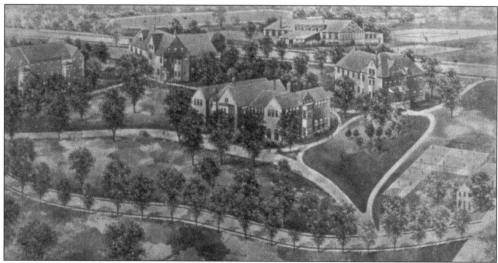

In 1892–94, four brick Tudor-style buildings were erected following Simonds' site plan—the main Simon Reid Memorial Hall, East House, Durand Cottage, and Remsen Cottage. The main architects were Pond & Pond, designers of the Hull House complex in Chicago. Cobb designed Remsen Cottage in 1894, in memory of a sister of Mrs. Warner's, one more on the list of several buildings contributed by him to the expanding Lake Forest University. (Coll./TG.)

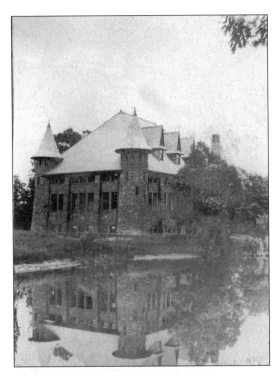

One key feature of the 1893 O.C. Simonds plan for the University Campus, now Middle Campus of Lake Forest College, is this pond—a dammed-up ravine just south of the 1891 gymnasium designed by Cobb. Created in the 1880s, Simonds apparently envisioned this pond as a natural design focus. This remained an element of the campus landscape until the mid-1930s. (Coll./TG,)

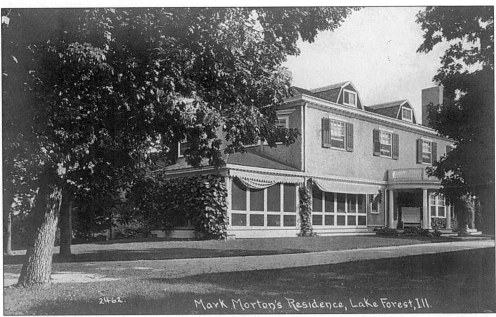

The Mark Morton estate of 1894 (demolished) was located on the south side of Woodland Road, between today's Sheridan Road and Meadow Lane. This stuccoed colonial-style house, with its rounded porch at the entry and gambrel-roofed dormers, reflects the post-Columbian-Exposition move away from the asymmetrical Queen Anne style, seen in the Manse and in the Tuttle House, to the more simple and classic colonial forms, as displayed in smaller 1893 Exposition pavilions. (Paddock.)

In 1894, William Henry Smith, heading the Associated Press in Chicago, built a second home to replace one on the bluff south of "Fairlawn." This new Green Bay Road house, a formal colonial of stone, was designed by Cobb, just north of the architect's own farm property, where today it stands facing Pembroke Drive and also looking west toward the Skokie River. Smith's first Lake Forest home in 1875 had been south of Spring Lane on Lake Road, according to Halsey (1916, 128). (Paddock.)

David B. Jones (died 1923), a Princeton graduate and mining and real estate entrepreneur, also had Cobb design for him an 1895 Green Bay Road colonial manor house just south of Deerpath Road, even larger than "Lost Rock," called "Pembroke Hall." The handsome neoclassical stable, just north of the house, and quite large as well, was the home of his grandson, the late architect Edward Bennett Jr., a 1970s founder of the local preservation group. (LF/LB Historical Society.)

This 1885 Oakwood Avenue vernacular frame house with Stick-style features was the home of Scottish immigrant Alex Robertson and later was purchased by David B. Jones to house his chauffeur. (Paddock.)

This 1899 Queen Anne cottage, perhaps designed by Cobb, pictured as it appears today with a small tower on the southwest corner, was also owned by Jones for servants' quarters across Green Bay Road from Pembroke Hall. (Paddock.)

Mrs. Ambrose Cramer, married to an agent for mining machinery, was one of three Corwith sisters with houses along the bluff south of Ferry Hall. The high Georgian style is seen in this view of the lake front facade of the 1896 Rathmore by Boston architect F.W. Stickney; the grander west facade, pictured in the *Preservation Foundation Guide*, shows a semicircular porch two stories high with a flat roof supported by four Corinthian columns. This higher style had also been in evidence at the 1893 Exposition. (Paddock.)

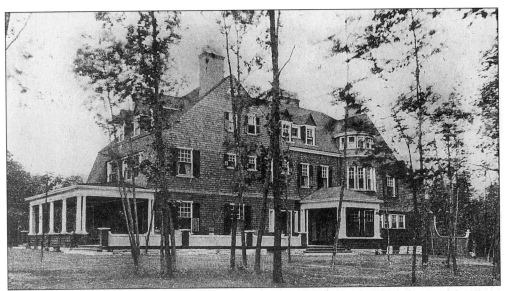

Also completed in 1896 was the Shingle Style cottage (demolished 1950s) designed for Cyrus McCormick Jr. and his spouse, Harriet Hammond McCormick, by Jarvis Hunt, nephew of Beaux-Arts architectural pioneer Richard Morris Hunt of New York. Young Hunt came to Chicago in 1893 to work on the Exposition. Named for Thoreau's simple Walden retreat, the house was meant to seem diminutive, secondary to the naturalistic landscape, which was designed by Warren Manning. (Lake Forest/Lake Bluff Historical Society.)

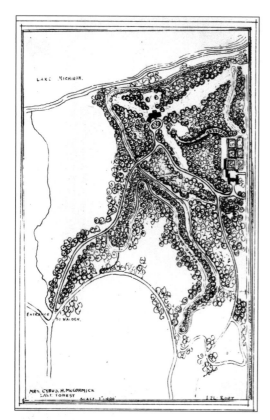

Manning visited Walden every spring from 1896 to 1935. He guided the development of more than 100 acres in the southeast corner of Lake Forest. This sketch plan of Walden was prepared by landscape architect R.R. Root for a book of garden plans for Garden Club of America visitors to Lake Forest in 1919. The sketch reveals here Manning's Olmstedian reliance on the local terrain for his design, with the dominant ravine and lake bluff. (Lake Forest Garden Club/Coll./TG.)

The key features of the Walden landscape plan were long vistas and sinuous drives with bridges, both for striking views. This snapshot from the papers of Lilace Barnes shows what today is known as the Walden bridge, designed from a structural concept by McCormick himself, according to Manning who wrote a history of the estate in 1933. The local Preservation Foundation and the City of Lake Forest restored this bridge in the 1990s, one of the few reminders of this stunning estate creation, subdivided in the 1950s. (Barnes/Coll.)

This ancient plan, from the files of the almost century-old Griffith Grant and Lackie firm, shows the layout in 1891 of the Calvert nursery on Illinois Road, at the west end of Rosemary Road. This land had come to city founder (in 1861) Frank Calvert, a landscape gardener, and was developed by him with greenhouses, two frame dwellings on the south, and lots of land to prepare plants for local gardens. He certainly is among the earliest documented landscape gardeners in the Chicago region. (Griffith, Grant, & Lackie/TG.)

This view shows the appearance today of what may be an original Calvert house. Frank Calvert had come from Britain around 1850, but a decade later he was helping set up what almost immediately was recognized as one of the most beautiful suburbs in the nation. This house at the social summit of the town within a town, across the street from the house later built by banker Frank Read, and just south of local grocer Gunn's Queen Anne house, on the northeast corner of Rosemary and Illinois Roads. (Paddock.)

The British sport of golf long had interested Chicagoan Charles Macdonald, but the arrival of a British contingent in the city for the 1893 Exposition also stimulated MacDonald to try to entertain them with some temporary links. With Hobart Chatfield-Taylor's help, he laid out the Chicago area's first short course east of Fairlawn, Chatfield-Taylor's father-in-law's Lake Forest country place, partly on Forest Park at the bluff's edge (shown here) and also including the large Olmsted-style park of Fairlawn itself. Chatfield-Taylor's spouse, Rose, became an amateur champion within a few years. (Paddock.)

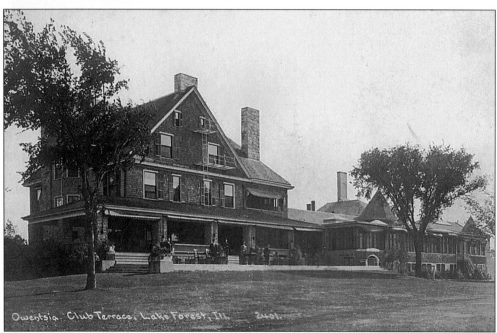

In late 1895, this informal golf club, having used the Leander McCormick farm on Green Bay Road at least for a season, organized itself as the Onwentsia Club, and took over the grand Cobb house and farm north of McCormick's. From the 1896 season on, this spacious park, designed by Olmsted, was the setting for this club's golf course—one of the area's earliest, though later than Chicago Golf at Wheaton. Chatfield-Taylor appears here on the left. (Paddock.)

Four

THE GREAT ESTATE ERA

1897–1917

Landscape architect and historian Norman Newton coined the term Country Place Era in his 1972 history entitled *Design on the Land* (M.I.T. Press), describing the period of estate building between the 1893 World's Columbian Exposition at Chicago and 1933, when Franklin Delano Roosevelt was elected president, ushering in changes unfavorable to large private properties. This phase, though somewhat muted locally after the 1929 stock market crash, continued in town up to the beginning of World War II in 1942. However, some such local ventures, perhaps the grandest in scale and complexity and also reflecting some of the greatest Chicago and U.S. fortunes, came in the decade prior to this country's entry into World War I and also to the Russian Revolution, both in 1917. Another phase of Lake Forest estate building reached a peak between 1924 and 1934, following a post-war Depression, but this later period can be included, perhaps, in a future volume.

This album's high point occurs in the early twentieth century, when Edith Rockefeller McCormick, daughter of John D. Rockefeller, who then was the richest American, and J. Ogden Armour, who in this period was the second richest American, were building their great Lake Forest estates. By 1923, Armour's fortune was gone, and by the early 1930s, so was Edith's. Also, it was in this pre-World War I phase that F. Scott Fitzgerald was smitten, futilely, with Ginevra King; the image of Lake Forest he perpetuated was formed for him in that pre-war moment. Finally, when the Garden Club of America, which had been founded in 1913, visited the local Garden Club in 1919, now the Lake Forest Garden Club, they were dazzled by the beauty and concentration here of the garden arts—in effect the pre-war accomplishment. This experience is recalled in a little book of plans done by landscape architect Ralph Rodney Root for the local club to hand out to the 1919 visitors. Root also published an article in January of 1924, in *The Architectural Record* including many of these plans. It is this largely pre-war project, for the visit had been proposed earlier, which convinced the East Coast estate establishment that the locals excelled not just in wealth, but in style as well.

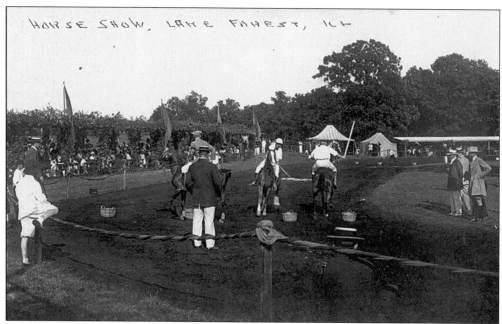

The Onwentsia Club, starting in 1896, drew more and more of the Chicago social elite into an orbit not unlike that of Versailles in the era of the Sun King. The classic annual fete of the early 1900s was the horse show, where all ages paraded and competed, and where everyone came to see and be seen. Here steel baron Edward L. Ryerson looks on at the front of the group on the right, watching the two competing horsemen. (Paddock.)

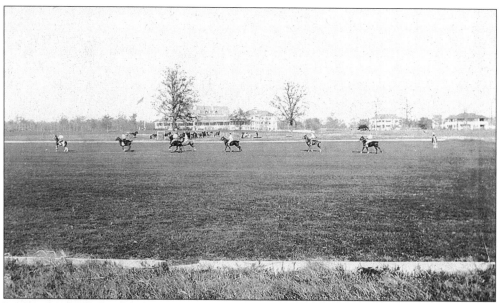

Looking toward the former Cobb house, now the clubhouse, from the west end of the Onwentsia grounds, this photographer has captured his own shadow as well as the afternoon polo match in progress at full pitch close to the clubhouse. Visible, too, on the right or to the south of the clubhouse, were two buildings (demolished) with apartments to house Chicago-based members out for the weekend. (Archer/Paddock/TG.)

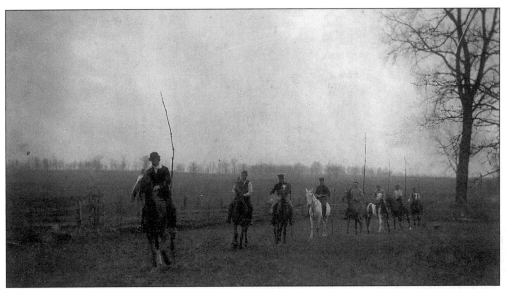

Polo had been introduced in 1896, Onwentsia's first season. In charge of the polo ponies was Swedish-born Gus Malmquist. Here he is pictured on the left in a derby hat, leading stable personnel in a practice drill for the ponies. Arpee (144–45) credits Malmquist with bringing "the first polo ponies to Lake Forest." Malmquist visited the Dakotas and Montana to find and ship back his stock. (Weber.)

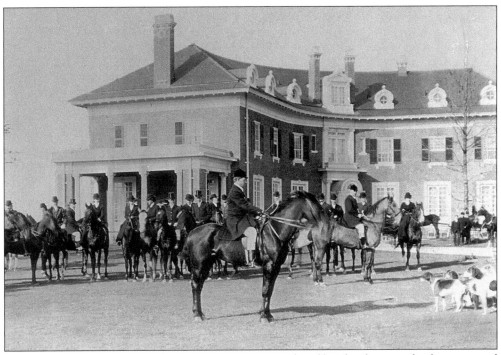

The third in this trio of British aristocratic sports—with golf and polo—was fox-hunting, and the club's hunt before World War I ranged west as far as the Des Plaines River. Here the club hunt gathered in front of Westmoreland (architect James Gamble Rogers, 1903; demolished), the home of A.B. Dick, the entrepreneur for the first duplicator, and his family. (Coll./TG.)

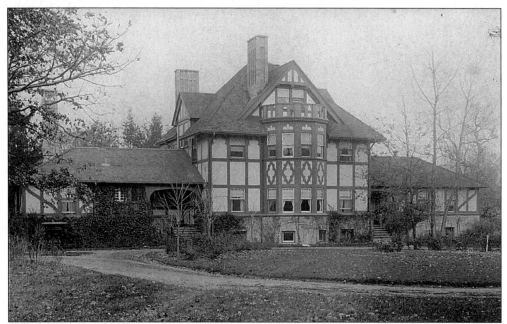

The community's first hospital, operated by the Lake Forest Hospital Association, the Alice Home on Lake Forest College's North Campus, was a gift in 1899 of the Henry C. Durand family, who had given the institute (1892) as well; it was named in memory of Mrs. Durand's sister, Alice Burhans. The architects were Frost & Granger. After 1940, the building became Alice Lodge, a women's residence for the college until the 1960s, when it was torn down. Its foundations can still be seen on the east side of the campus, on the ravine edge. (Coll.)

Today's South Park became the site of the Contagious Hospital, a branch of the Lake Forest Hospital Association, early in the twentieth century. The low building shown here was an important community resource, according to a 1921 hospital association report—one of six isolated buildings, with a total of 22 beds. In this era before antibiotics and some vaccines, persons were quarantined for diphtheria, typhoid, and scarlet fever especially. (V. Julian.)

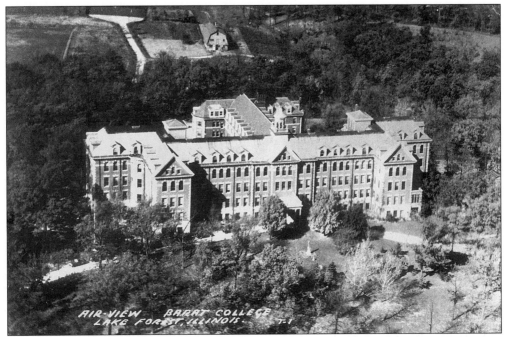

South of the Contagious Hospital, Barat College was built in 1904, a still-impressive colonial revival edifice for the Sisters of the Sacred Heart. On the southwest fringe of the original 1857 street plan for Lake Forest, the location of the new women's college represented the social ambitions of the mostly Irish-descendant Catholic community of Chicago in an assimilationist era. The design was by Egan & Prindeville. (Cutler.)

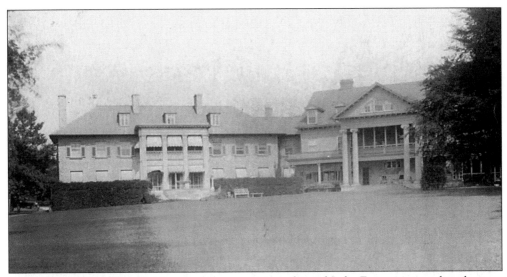

Louis F. Swift's Westleigh epitomized the extension of social Lake Forest westward at the turn of the century. The Swifts' own colonial-revival place was built in 1898, south of Onwentsia on Green Bay Road (now on Foster Place), designed by Chicago architect William C. Zimmerman (right, demolished), with a 1916 wing by Shaw (left, extant). Swift, eldest son of grain merchant and meat packer Gustavus Swift, ran the firm and also collected west Lake Forest real estate. In 1924 the Prince of Wales (later Edward VIII) was entertained here. (Paddock.)

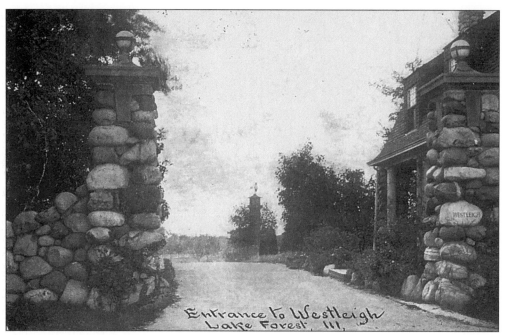

The entry gate and gate house to Westleigh on Green Bay Road (demolished), show architect Zimmerman drawing on the materials and forms of architect H.H. Richardson (1838–1886). But the detached gatehouse is an English Tudor feature, then a vestige of medieval defense, installed at the entrances to new-money estates of that Renaissance period by merchants seeking the trappings of feudal position. (Coll.)

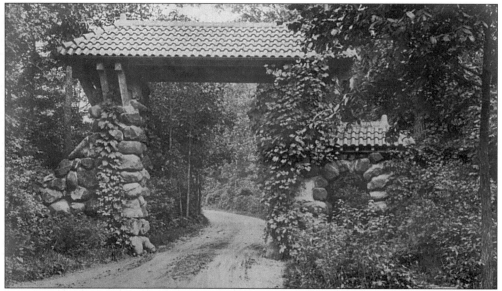

An interesting variation on the theme was this high-profile turn-of-the-century entry gate to private Stone Gate Lane, a drive south from the east end of Illinois Road. Here the gate, in the same Tudor/Richardson vocabulary, announces the break between the public roadway and the private drive to a subdivision of multi-acre estates. It was the creation of James Gamble Rogers, who had married a daughter of the then-nearby Albert Days. (Paddock.)

Miss Helen Culver's Rookwoods was the first such place built on what today is Waukegan Road, just north of Deerpath Road on the west side, with a sunset view to the western branch of the Skokie River. This 1900 apparently Pond & Pond-designed home was for a remarkable Chicago real estate entrepreneur and philanthropist. The architecturally and historically significant house, which stands today on Ashlawn, still is a stately (if hemmed in) reminder of its important builder and architects. (Paddock.)

This segment of a plan of the Rookwoods estate shows its original grand scale and view west. It comes from the archives of the 1903-founded Griffith, Grant, & Lackie firm, probably from the period after Miss Culver's 1925 death. John Griffith, who had been carriage driver and then farm manager for Swift, appears to have continued to work with him on local development. Surviving records show that he actively solicited Chicago prospects. Miss Culver would have approved. (Griffith, Grant, & Lackie/TG.)

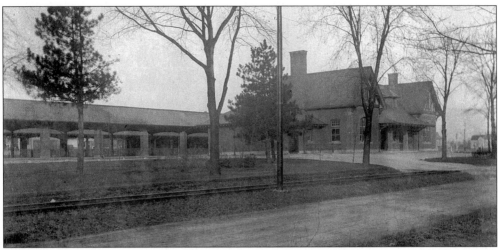

The growth in traffic for the Onwentsia Club also led to a new train station, the Chicago & Northwestern's largest for a Chicago suburb, coincidentally for the home community of the line's president, Marvin Hughitt; its vice president, Hiram McCullough, who was a son-in-law of Hughitt; and also of architectural partners Charles S. Frost and Alfred H. Granger, both Hughitt sons-in-law as well and the architects of the handsome new station. (Paddock/TG.)

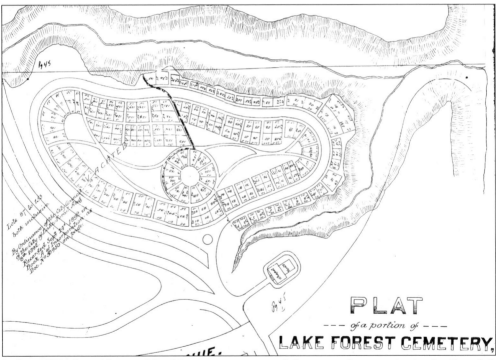

In his 1857 plan, Almerin Hotchkiss, an experienced designer of cemeteries in the East, left space for a cemetery at the north end of Lake Road. According to cash book records, the Lake Forest Cemetery Commission didn't get underway until 1881–82, when Chicago's first Paris-trained architect, Colonel William LeBaron Jenney (1832–1907), designer of the Chicago West Side parks in 1870–71, created this plan, successor to an earlier gardenesque plan, perhaps never implemented. (City/TG.)

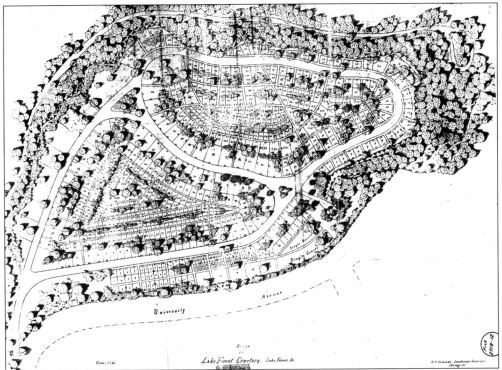

In 1900–01, O.C. Simonds proposed a revised cemetery plan with a new layout both showing the present-day tree-dominated naturalistic landscape, and also a proposed (but not implemented) more public entrance at the east end near what had become Sheridan Road, by then a through street as chronicled in Michael Ebner's 1988 book, *Creating Chicago's North Shore*. (City/TG.)

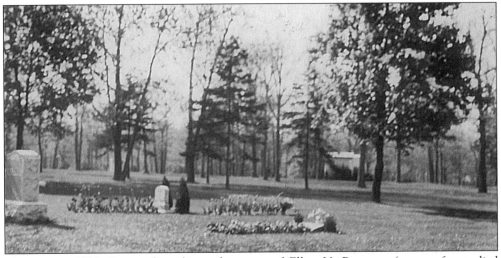

This winter 1932–33 snapshot shows the grave of Ellen V. Peterson (center, front; died December 1932), spouse of Christie Peterson, who was later employed as a plumber in the Strenger family firm. Other monuments shown here were for the Marwede family (left) and Jean Robertson (died 1932). This photo records an earlier level of development of the trees apparently planted, according to the 1900–01 Simonds plan. (Paddock.)

The Winter Club complemented the private Bell School, adjacent to the Presbyterian Church, by providing a year-round athletic facility, according to Brace Pattou. The centerpiece was a large pond of natural ice for hockey and figure skating. At the beginning of the twentieth century, a great toboggan slide soared over Sheridan Road from the club. The 1902 clubhouse was designed by Charles S. Frost. (Coll./TG.)

This photo from the late Ruth Elting Winter (Mrs. Edwin S.), now in the college archives, shows the Winter Club cast of one of young Louis Laflin's (back, fifth from right) operettas, "Queen of Hearts, performed August 4, 1911." Laflin, the descendant of an old Chicago family, devoted himself to study and writing, including active participation in the long-standing local Play-Readers couples group, for which he wrote many original and often occasional plays. (Coll.)

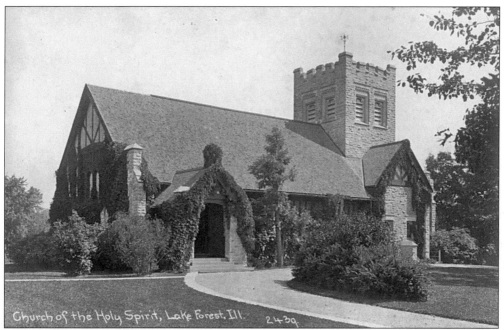

Church of the Holy Spirit, Lake Forest, Ill. 2439

The Episcopal Church of the Holy Spirit was organized late in 1898, after the Onwentsia Club was founded, all Protestant denominations having been welcomed in the Presbyterian Church of Dr. McClure. Its village-scaled English Gothic sanctuary on Westminster Road, west of Sheridan Road, was built in 1902, designed by Alfred Granger, with later additions. (Paddock.)

Miss Culver's sagacity in being the first on Waukegan Road soon was confirmed by stories in the *Waukegan Sun* in 1904, announcing the arrival of the automobile in Lake Forest and also of the meat packers, who had invaded the Waukegan Road district south of Rookwoods. Cars that year cut the travel time to the station and effectively extended the radius of acceptable places for development. The quiet rural scene here was along Green Bay Road as an automobile and a horse-drawn buggy meet. (Mellick/Coll.)

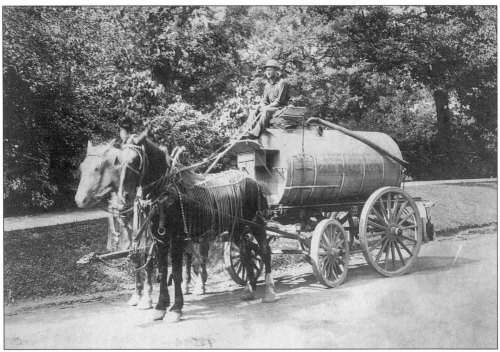

The roads had to be decent. A private initiative, the Road Association, worked on improving the roads to reduce travel time. Here is an early horse-drawn tanker for oiling the gravel roads. The packers, this time J. Ogden Armour and his associate Arthur Meeker, both were lured by the improved access to open land and also driven away, according to the gleeful Waukegan reporter, by the south side stockyards' smell wafting over quaint old Prairie Avenue. (Archer/Paddock.)

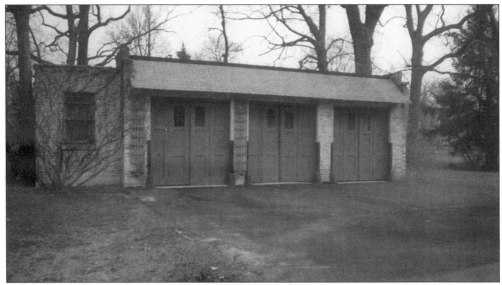

Shown here is the Charles B. Pike family's one-story common-brick garage a block west of their bluff's edge home, one of the few such estate structures in the community still standing and used as a garage. Though frankly utilitarian in design, its trellises between the doors and exterior wood trim betray the talent of its 1917–18 architects, David Adler and Robert Work. (Bills.)

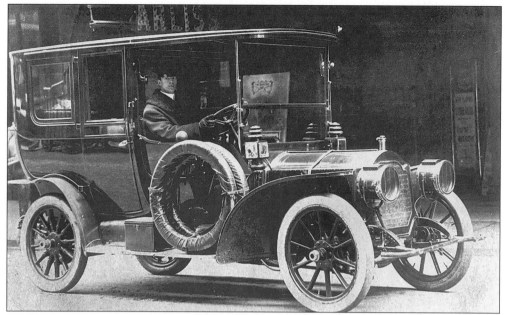

No longer extant is Cyrus McCormick Jr.'s garage complex, which was located north of Westleigh Road, east of the still-extant stable complex, near Circle Lane. Here he stored his Packard cars. Though this Chicago view indicates the McCormicks were in town (Burton Place), this (or a similar) touring car also was used at Walden, according to Anthony Cascarano, who lived in the garage complex, 1925–39, to drive the elderly Mr. McCormick (died 1936) around the estate. The chauffeur here is David Julian. (W. Julian.)

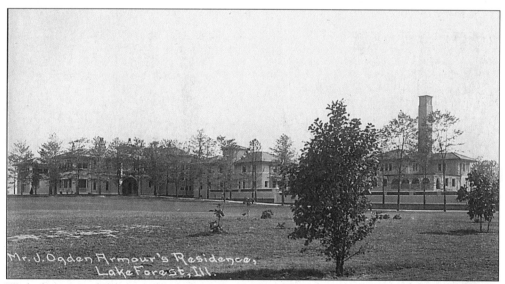

With the automobile's arrival in Lake Forest came the development of the 1,000-acre J. Ogden Armour estate, Mellody Farms (1904–08). In 1904, Edith Wharton's *Italian Villas and Their Gardens* had appeared in book form with ravishing illustrations by Maxfield Parrish, stimulating a new vogue. Armour was the second-richest American, after Rockefeller, and the successor to his father's (Philip Armour's) empire of grain trading and meat packing interests. Today the villa houses Lake Forest Academy. (Paddock.)

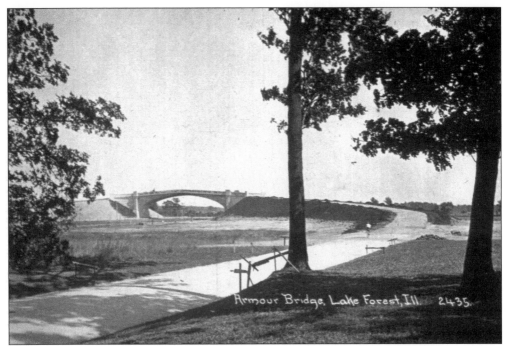

The house was the culmination of a trip along an O.C. Simonds-designed roadway and across the Simonds-designed bridge over the Milwaukee Road tracks. The trip had begun with entry through stately classic gates (now the property of Lake Forest Open Lands), off Waukegan Road, and designed (with the classic gate house) by estate architect Arthur Heun. (Paddock/TG.)

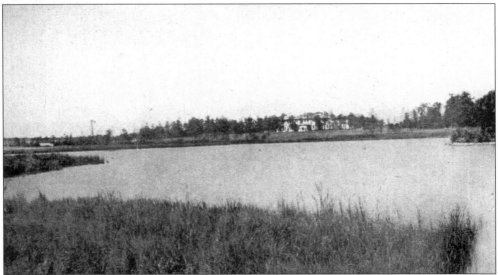

This pond appeared along the drive just west of the railroad tracks, part of Simonds' English-landscape/Prairie-Style development of the flat site, at which author Arthur Meeker Jr., who had summered at the estate just south in his childhood, poked fun in his 1949 novel, *Prairie Avenue*, of the improbably Italian features on the pancake-flat open prairie dotted with saplings. However, almost a century later the mature trees surrounding the villa speak to the vision of those who planted them. (Coll./TG.)

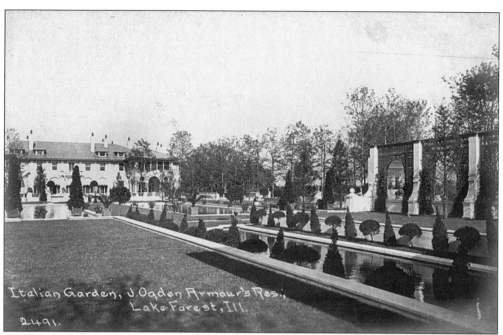

West of the villa were Heun's Italian-inspired formal gardens, with hard scape of concrete. A casino both terminated the view west from the villa and also looked over the stunning lake or pond further west. The pergola-like structures around the central water feature framed the vista west and contributed to the sense of garden rooms, as suggested in Edith Wharton's 1904 *Italian Villas and Their Gardens*. (Paddock.)

Lake Forester Charles Dyer Norton played a key role in Chicago and Lake Forest's involvement in the City Beautiful Movement—both convincing Daniel Burnham to lead the Burnham and Bennett Chicago Plan of 1909 effort and also promoting a Beaux-Arts plan for Lake Forest College, a 1906 plan by Benjamin Wistar Morris and Warren Manning. In 1909, he left town to be secretary to President William Howard Taft in Washington. (Coll./TG.)

The Norton place at 550 East Deerpath Road incorporates the remains of the original Sylvester Lind house of 1859. It was designed by architects Schmidt, Garden, and Martin in 1906 (the designer for the firm, Hugh Garden, later lived nearby on Washington Road). (Paddock.)

The Nortons' landscape was designed by Prairie-Style master Jens Jensen, whose grandson, Bruce Johnson, lives in Lake Forest today. Jensen's body of design work in Lake Forest before 1935 included at least 40 private commissions. His Prairie-Style work was characterized locally by forested buffers between the streets and lawns in front of houses, the use of native plants and materials, and the restoration of regional elements, like naturalistic (moraine-like) limestone water features and outcroppings. (Johnson.)

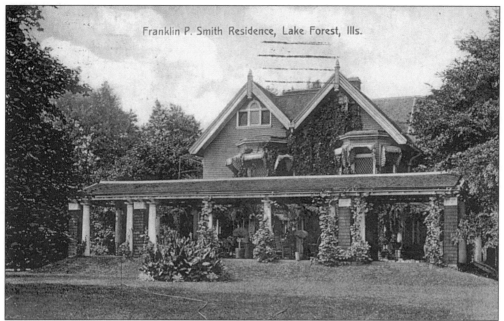

Franklin P. Smith Residence, Lake Forest, Ills.

Franklin P. Smith, a wrought iron fence manufacturer, married the only daughter of Henry C. Durand, Daisy, and lived on the family estate just west of the college and the Durand Institute that Durand had donated, on Deerpath Road. This house apparently was designed around 1900 for the senior Durand, but he died while it was under construction. Landscape designs by Simonds (1912) and Benjamin Marshall (*c.* 1917), were demolished, with Smith's own iron fence, in the late 1990s. (Paddock.)

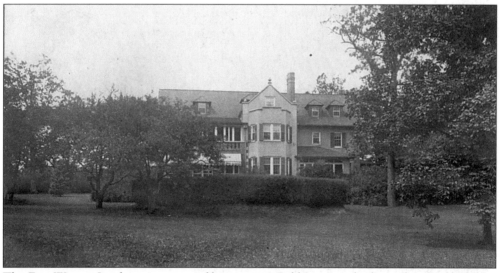

The Ezra Warner Jr. place, just west of his parents' Oakhurst, was built on the site of Roxana Beecher's school, 1860–63, which was then moved to its location on Westminster. The new early-twentieth-century house was designed by Frost and Granger, and bears the apparent signature crenelations—a recollection of Frost's role in the Potter Palmer mansion on Lake Shore Drive. It was featured in a volume of the annual *American Country Houses* series. (Paddock.)

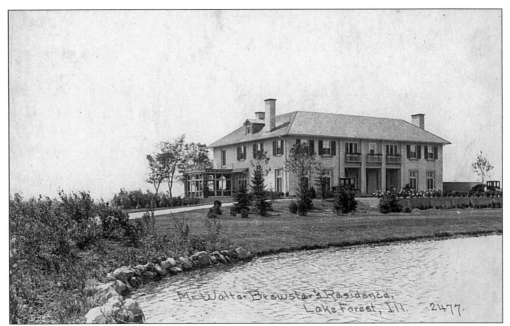

This is the 1911–12 estate of Walter and Kate L. Brewster, the house by architect Howard Van Doren Shaw (1879–1926) and the landscape by the Olmsted Brothers (John Charles Olmsted, 1852–1920, and Frederick Law Olmsted Jr., 1870–1957), according to records in the Library of Congress's Olmsted Papers. Kate Brewster was a leading member of the early Lake Forest Garden Club and wrote *The Little Garden for Little Money* (1924), still a useful no-nonsense local guide. (Paddock.)

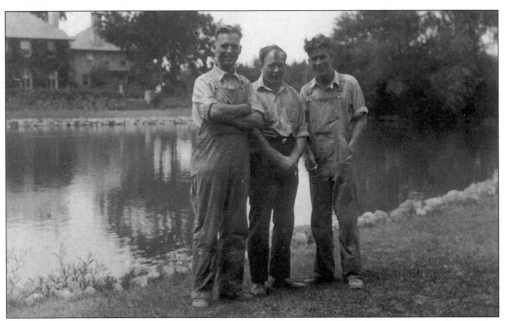

Here assisting in what was by no means a "little garden" in its hey-day are, from left to right: an unidentified person, Dage Moller, and Eric Mattson. Though subdivided, the house and pond have survived—the former reconstructed after a fire. (Chope.)

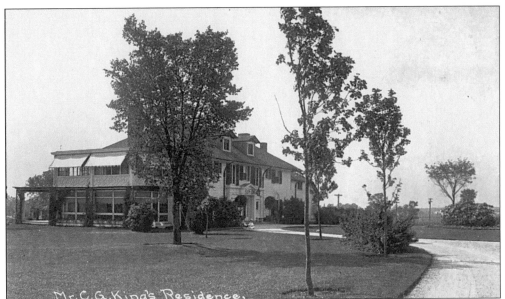

Here is a *c.* 1907 view of the Charles Garfield King home, designed also by Shaw on former Swift land made more valuable by the new automobile access as far west as Ridge Road, today south of Route 60. There it survives essentially unchanged from when F. Scott Fitzgerald was smitten by banker King's daughter, perhaps shown here, Ginevra. The nearby King polo barn (still standing) and the Onwentsia polo field not far east would have contributed to the background for *The Great Gatsby*. (Paddock.)

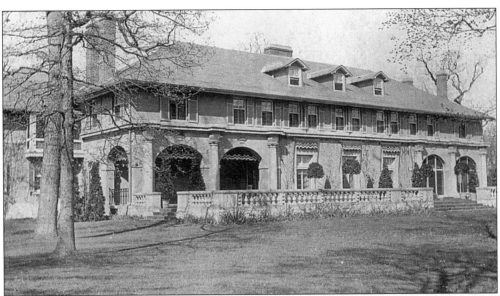

Not clear from Virginia A. Greene's very useful 1999 *The Architecture of Howard Van Doren Shaw* is the presence of two E.L. Ryerson estates by Shaw in Lake Forest, a 1906 place and also Havenwood (1914; demolished), near Sheridan and Ringwood Roads, pictured in her book (p. 69). Shown here is the garden facade of the 1906 house (also demolished), further north on Sheridan Road, on the northwest corner of Sheridan and Woodland Roads, later known as the Thorne or Reuben Donnelley place. (Paddock.)

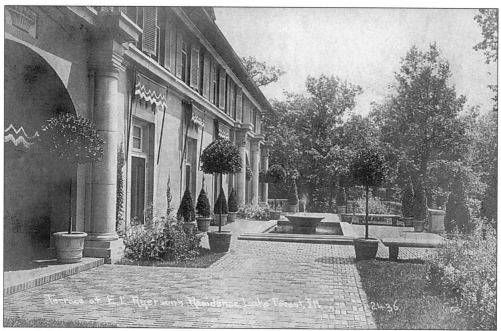

This view of the terrace, along the garden facade, illustrates the formality and French inspiration, with the topiary potted trees. Edward Larned Ryerson, discussed in detail in Leonard K. Eaton's 1969 book, *Two Chicago Architects and Their Clients*, was a south Chicago steel maker and lover of gardens, who moved a few years later to gain a larger palette for his landscape ideas. (Paddock.)

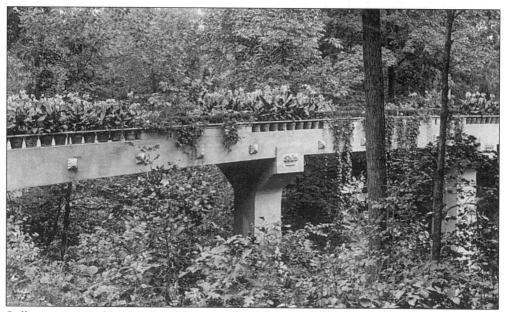

Still surviving is this significant Shaw-designed bridge, with his signature basket of flowers embossed on the structure, which led from the house to the gardens southeast across a ravine. This charming bridge, after 1930, led to the infill David-Adler-designed Edison Dick place on Woodland, built on the original Ryerson estate gardens. (Paddock.)

This long view back over the bridge to the Ryerson house shows the formal character of at least part of the eastern gardens in the foreground. A survey from the time, from the Griffith, Grant, & Lackie archives, indicates that much of this space was cutting gardens and greenhouses. (Paddock.)

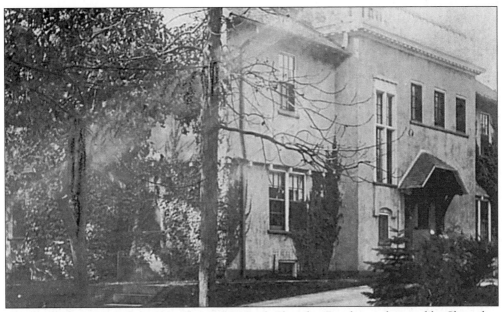

The 1906 Edward L. Baker place, now 1110 North Sheridan Road, was designed by Shaw, but in the English Arts & Crafts style with a pergola extending west of the house and integrating the stucco house and the garden. A plan showing the pergola, too, is in Virginia A. Greene's 1999 monograph on Shaw (p. 67). Baker was the heir to a Case farm equipment fortune, and the private printer (from his third-floor study) of the 1908 Arts & Crafts *Ragdale Book of Verse* written by Frances Wells Shaw, spouse of the architect. (Paddock.)

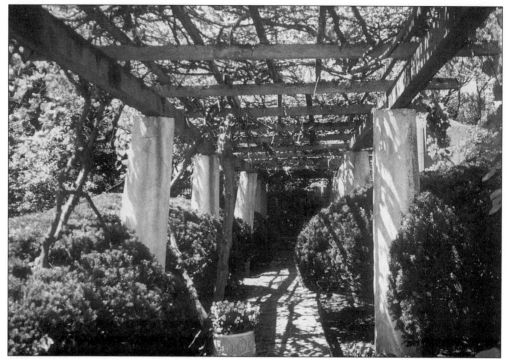

The Baker's pergola resembles one by M.H. Baillie Scott, also in 1908–09 for Undershaw, a cottage in Guildford, England, and pictured in Wendy Hitchmough's 1997 book, *Arts & Crafts Gardens*, (p. 169). In his 1906 book, *Houses and Gardens*, Baillie Scott promoted the pergola to pattern light and shade over a stone walk and added informal stone steps and walls for a homey, naturalistic treatment. (Paddock.)

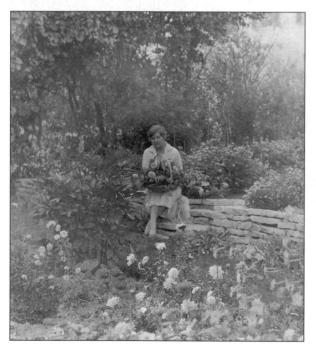

Here Frances Pratt Baker, spouse of Edward L., sits on Shaw's native-limestone steps and wall surrounded by her garden and holding flowers nurtured by gardener Sylvester MacDonald (1895–1981). Shaw visited Europe in 1900, his first trip abroad since his early 1890s study there. This 1906 garden and house illustrate how solidly Lake Forester Shaw was positioned in the mainstream of the English version of the Arts & Crafts Movement in his architectural design. (Paddock.)

The carriage house still stands as well, the childhood home of Shirley MacDonald Paddock and the location in which her Canadian-born/Scots-descendant father was the driver/gardener following the 1929 Crash. As the gardener, MacDonald tended the Bakers' greenhouse, entered flowers in Horticultural Society flower shows at Durand Institute on behalf of the estate, and in season delivered flowers often to Lake Forest Library, on the board of which Baker served many years as a trustee. (Paddock.)

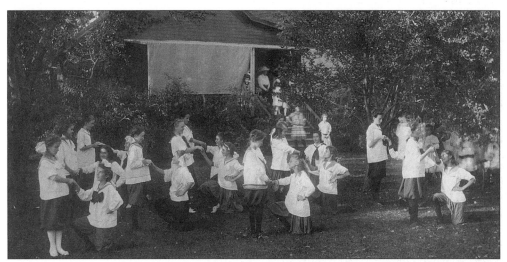

Amateur theater, one-acts, and pageants (as in this Campfire Girls production), were active local pastimes. The Aldis Playhouse stood on the now-demolished estate of Arthur and Mary (Reynolds) Aldis at the southeast corner of Deerpath and Green Bay Roads (now Open Lands Park), extending east to include the phone company building site. The estate also housed, over the carriage house, Maurice Browne, the English head of the Little Theatre in Chicago's Fine Arts Building (c. 1911–17), a cause supported by playwright and author Mary Aldis. (Lake Forest/Lake Bluff Historical Society.)

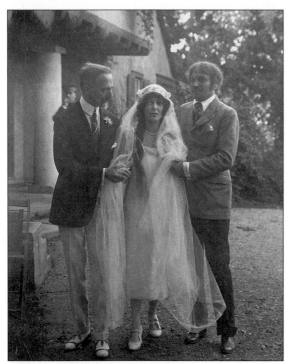

Here, architect Alfred Granger, Mrs. Howard Linn, and John Dorr Bradley act out a scene of a peripetic outdoor play at Howard Shaw's Ragdale, from a light August 1909 play, *The Heir of Mandeville Grange*, by the architect's spouse, Frances Wells Shaw. This Society production, much noted in the Chicago press, preceded a more high-profile, similarly wandering, outdoor play by Maeterlinck, in Europe, and of course Mary Zimmerman's recent Ovid production, in Chicago. (Hayes/TG.)

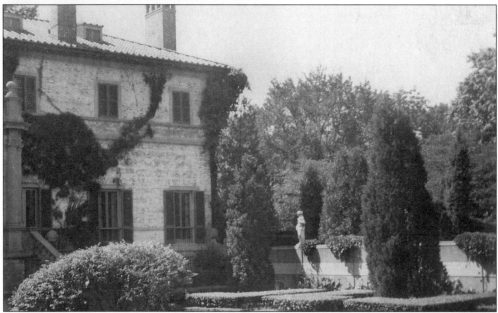

The Adler-and-Work-designed Charles Pike place (1917) was visited for the 1919 Garden Club of America annual meeting held on the North Shore. Its alley of marble Italian sculptures, probably disconnected in the chaotic European War, still were seen as striking a decade later when the club had launched a Lake Forest Foundation for Architecture and Landscape Architecture, bringing the best graduates in these professional fields to Lake Forest during the summers, 1926–31. Several sketches of this estate survive, made by Foundation students. (Bills.)

Five

THE GREAT ESTATES

VILLAGE AND TOWNSPEOPLE

Indications of the fact that in recent years, the social complexity of estate culture has become better appreciated appear in books of the last decade. In the 1997 (rev. 1999) British book by television producer Tim Smit on the restoration of the early-twentieth-century *Lost Gardens of Heligan* in Cornwall, also the subject of a British television series, the author describes the process of discovery and decision-making prior to restoring an estate. Initially discovering graffiti with the names of gardeners on the derelict grounds and then seeing their names on World War I memorials nearby soon after leads him to seek to resurrect their garden, finding these gardeners more sympathetic than an encountered descendant of the original owner/creator. Much closer to home than Cornwall, in their 1990 *Ragdale: A History and Guide*, architect Howard Shaw's granddaughter Alice Hayes and her daughter Susan Moon include, among the photo illustrations, images of Ragdale's wagon, horses, and stable man who lived above the barn, and also of a distinctly non-Society farm wife who was the Shaws' neighbor in the late 1890s. The Ragdale guide shows that support staff and simple neighbors were integral to early Lake Forest.

Especially with its unique and radically anti-urban 1857 plan for the area east of the tracks, Lake Forest originated as two communities—a retreat for elite, mostly New England-descendant Chicagoans, and a town based on the local industry, the estates of these wealthy city people. From the earliest times, smaller homes had sprung up on the periphery of estates and of estate development. But a whole town was built just west of "Lake Forest"—stores, businesses, stables, and modest homes. By the early part of the past century, this sub-community was growing as well, and even expanding east of the tracks—both north and south of the estate areas. Thus, a de facto town snaked along the North Shore Line tracks, east and west, supporting the development of estates. It, too, had its commercial interests, institutions, and culture. Like farm and mill towns, this community was well-versed in the crafts required of its industry, in this case estate construction and maintenance. Yet this town within a town's rich and unique tradition and contributions have only just begun to be understood and appreciated.

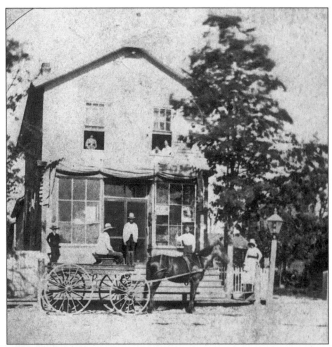

By the later 1860s, stores sprang up across the tracks from the 1857 street plan of estate lots. Here is pictured the general store of Francis Nelson Pratt (1825–1903), situated approximately in the location of the 1917 southern Market Square store group's intersection with Western Avenue (see p. 25). Pratt, Arpee chronicles, came to town in 1857 from Waukegan (to which he had previously immigrated by the Erie Canal) to help build the Old Hotel, the academy and the first bridges. He served as depot-master, with only six trains daily. (Coll.)

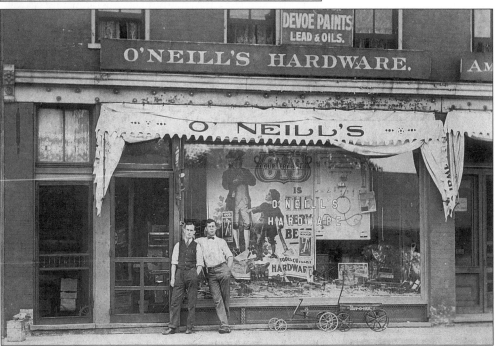

In 1868, according to chronicler Arpee, tin smith Joseph O'Neill and his family established their business on Western Avenue just south of Westminster Road. In 1869, they moved the business, including a hardware store, south to just opposite the depot. In the early twentieth century, this business relocated to the north side of Westminster Road just west of Western Avenue, where the business survived into the 1990s. Pictured here around 1910, across from the train station, is William J. O'Neill and William Dickinson. (O'Neill.)

This cottage still standing on the southeast corner of Westminster and Oakwood Roads, west of the tracks, has belonged to the Marwede family since 1916. Alfred Marwede was chauffeur to J.V. Farwell for 24 years. He operated a chauffeurs' supply business, and his son, Alfred Jr., started the Marwede heating oil firm. This cottage, already on a 1904 fire insurance map, appears to be one of the oldest surviving commercial district structures. (Paddock.)

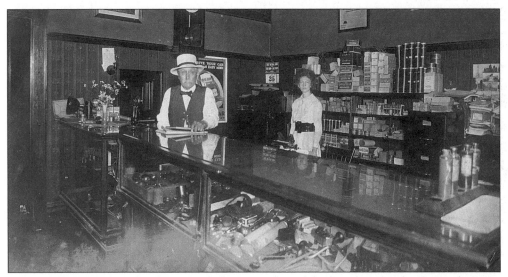

Shown here is another chauffeur supply business, that of the Wenban family. Patriarch Curtis G. Wenban appears here with Jessie Spelt. The Wenbans came from Diamond Lake in the 1870s, according to Arpee (97), with the children attending the Lake Forest University schools (Academy, Ferry Hall, and College). Other family enterprises included a funeral business (still in operation, but owned by former employees James Iacubino and Ted Larkowski) and a livery stable, and ambulance service. (Iacubino.)

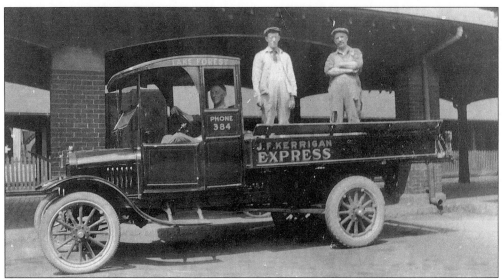

John F. Kerrigan (right, died 1934) established his estate-serving delivery business at 1240 North Sheridan Road (extant) c. 1890, aided by his father. John and his son, Francis J. (center), lived at 334 Granby Road, originally with horses and wagons in a stable at the rear. This photo at the station also shows Ernie Coombs (left). (Weston.)

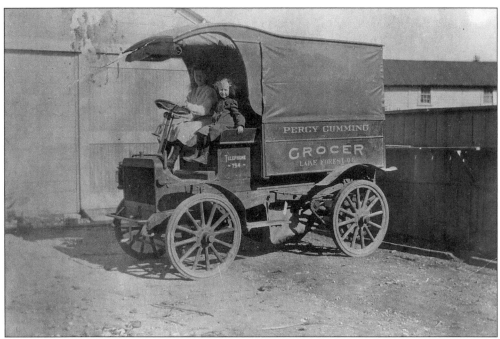

Grocer Percy Cumming was a turn-of-the-century retail grocer located on the strategic northwest corner of Western and Westminster Roads. This early-twentieth-century delivery van illustrates the service dedication of local merchants who supplied the estates. The truck, a Randolph, is shown with Ruth Cumming O'Leary (Mrs. John) and her sister, Grace. (O'Leary.)

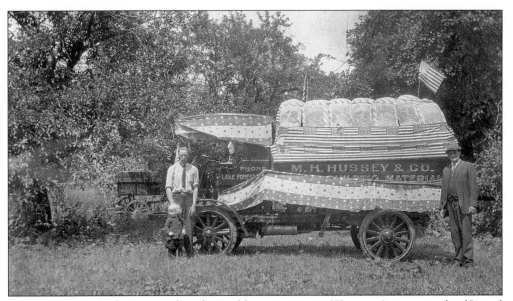

Michael Hussy's feed, grain, coal, and gravel business was on Western Avenue north of Laurel Avenue. This 1923 view shows Frank Butterfield, a Hussy employee; his daughter, Ruth; and on the right, apparently, Mr. Hussy. (O'Neill.)

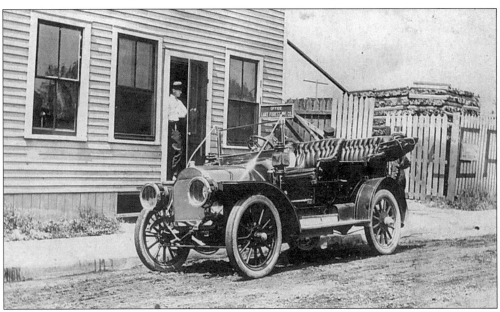

Elbert Parshall was employed by the landscape enthusiast Edward L. Ryerson (see pp. 6 and 56), who built two Shaw houses and adjacent gardens (see pp. 75–77 for the first; also Havenwood) before World War I. Here his son, Elbert, is shown at the wheel in front of Lake Forest Lumber Company, which later became Wells & Copithorne (demolished), presumably in a Ryerson automobile. (V. Julian.)

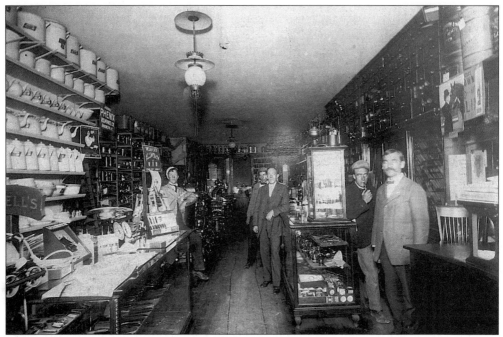

This early 1900s interior view of Harder's Hardware, on Western Avenue between Deerpath and Westminster Roads, shows (left) Leon Wells, later proprietor of Wells & Copithorne, a hardware store which later merged with Lake Forest Lumber Company. (Wells.)

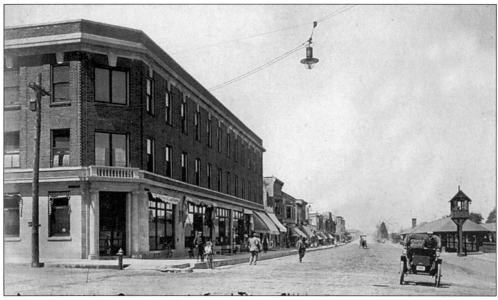

Anderson's second store, west of the tracks, was on the south side of Deerpath Road facing Western Avenue at the intersection, according to Arpee. Anderson later moved across Deerpath Road to the northwest corner, and built the present Georgian building there in 1904, designed by then local architect James Gamble Rogers. This view shows Western Avenue, with its businesses early in the century, with the now-demolished train signal tower, and with the preserved station beyond, far right. (Paddock.)

Frost & Granger also apparently designed a similar English-Tudor business block, the Griffith Block, also in 1904, just south of Westminster Road on Western Avenue and shown here on the far right in this photo of the period. This building, with its gables and crenelation recalling other Frost & Granger work at the time locally, brought the English traditional style across Western from the station, and joined west of the tracks the already-constructed city hall and fire station. (Paddock.)

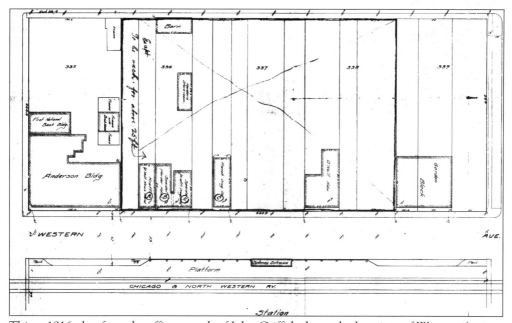

This c. 1916 plan from the office records of John Griffith shows the locations of Western Avenue businesses, between the Anderson and Griffiths buildings, south and north respectively. These were, south to north, Krafft's, Speidels, French's, and O'Neills. (Griffith, Grant, & Lackie/TG.)

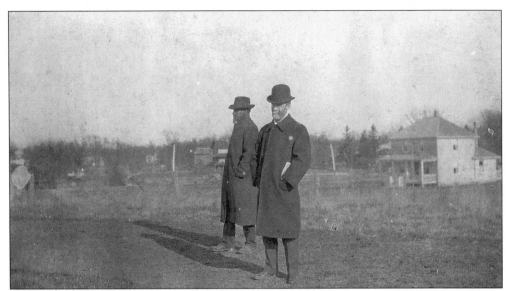

About 1910 the College's Farwell Field, Professors Schmidt and Halsey are apparently watching a late-fall football game or practice. Beyond them is the original African-American community in town, which built up around the other three corners of the intersection of Illinois and Washington Roads. On the right is the Matthews' home (extant), while seen on the northeast corner, apparently is the home (demolished) of Alexander Marshall, longtime custodian for the academy. (Coll.)

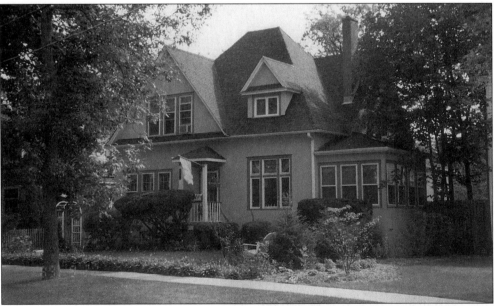

Just south on Illinois Road was the German settlement. Here, on the southeast corner of Washington and Woodlawn Roads, is the still-extant Lindenmeyer place. From this family came Edgar Lindenmeyer, longtime Lake Forest High School athletic coach, for whom Lindenmeyer Field is named; Katherine, who married Melville Lackie, nephew of John Griffith and later successor to his business interests; and Joseph Lindenmeyer, whose landscape firm succeeded the pioneer Calverts near Illinois and Rosemary Roads. (Paddock.)

British-born John Griffith (right) entered the employ of Louis F. Swift on his Westleigh Farms estate in the 1890s, rapidly rising from coachman to farm manager, and in business for himself after 1903, though apparently representing Swift interests in local real estate development. Griffith's assertive marketing techniques targeted prominent Chicagoans, who played a key role in the expansion of Lake Forest early in the twentieth century. Here he is pictured on a trip to view Western business ventures with his spouse, Mary C., center, but apparently delayed. (Griffith, Grant, & Lackie.)

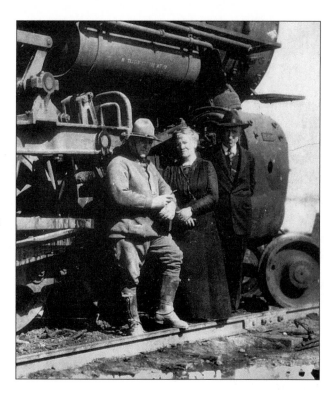

This view shows the location (demolished) of Griffith's real estate rental, sales, management, loan, and insurance business for its first decade after its 1903 founding, on the south side of Deerpath Road west of Western Avenue. (Griffith, Grant, & Lackie.)

This view of the North Shore interurban rail station represents the expanded transportation possibilities, which facilitated development of the support community. This line enabled the local public school district to drop its inadequate efforts at high school level instruction (since estate children attended local or eastern private schools) at the turn of the century in favor of the new Deerfield-Shields Township High School, an arrangement which lasted until the mid 1930s. (Cutler.)

Also, the closely-spaced stops in town (south of this station, Calverts near Frost Place and Farwell's Crossing at Ryan Place and north, at Scott Street and Noble Avenue) made new neighborhoods possible for the support community developed there by Griffith. This view north of Woodland Road shows Griffith Road resident James Iacobino mowing the lawn of the traffic island at the intersection with Griffith Road, east of the tracks. (Paddock.)

The January 2, 1958 *Lake Forester* recounted the history of the 183 gas streetlights in town (thought to be the only ones in the Midwest), first installed in 1916 as kerosene lamps. Later they were converted to gas and tended by city employees including Stanley Wells beginning in 1928, who visited each weekly to regulate its clock/controller. Though electric fixtures replaced these in estate sections, they survive in places like Griffith Road and in Griffith's 1914 south subdivision east of Farwell Crossing (Ryan Place today), two historically significant, estate-related districts. (Paddock.)

The horse's collar identifies this as the wagon of early contractor "T. Appleton." Thomas Appleton (1846–1925), according to the 1900 census, was a contractor locally; he also served as Shields Township Supervisor in 1905 (Halsey, 1912). The young man may be Tom Thompson Appleton (1875–1909), a son. The senior Appleton's daughter, Mabelle (1882–1950), taught at South School. (Archer/Paddock.)

John Niemeyer was an estate contractor in the early twentieth century. This on-site group included, from left: carpenters George May and Roy Webb, John Niemeyer Sr., John Jr., and Frank Niemeyer. Frank's son, James, recalls that the firm built the house at 85 East Westminster, which was designed by Frazier & Raftery, according to the 1995 Green Bay Road National Register Historic District application (100). George Niemeyer (1908–1989), brother of Frank, was a partner in the contracting firm after serving in the state and local police, 1934–41. (James Niemeyer.)

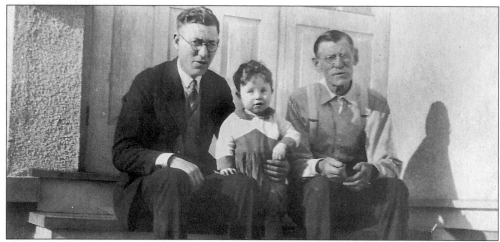

Another local contractor, Willis Wesley Griffis Sr. (1855–1927), came to Lake Forest in 1892 from Ontario, at the outset of the estate era's major phase of development. Also in the millwork business, Willis Griffis turned his operations over to his two sons, James and Harold, in 1922—according to the *Lake Forester*, April 8, 1927. The second Willis, left, later operated the Griffis drug store. Shown here are three generations, each named Willis Griffis. (Griffis.)

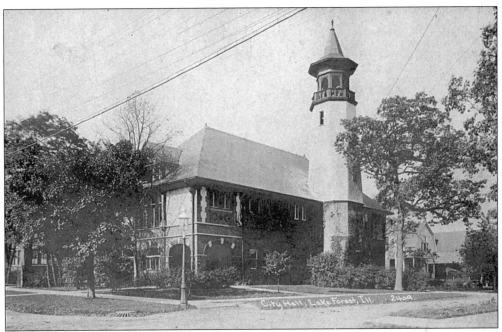

In 1899, the completion of a new city hall to house the community's fire, police, library (new in this facility), and administrative services, designed by Frost & Granger and constructed by Perry Hendershot, marked a significant change in the architecture of the commercial district west of the tracks. For the first time, architecture commensurate with that of the development in the original 1857 town plan east of the tracks was employed. (Paddock.)

So genteel was the new town hall building that it did not house something as plebeian as a jail. Instead this function was relegated, according to *Lake Forester* coverage of the time, to a less populated and visible stretch of Western Avenue south of Woodland Road, at the Lake Forest (later Wells & Copithorne) lumberyard complex. When this venerable business yielded to the new Arts-and-Crafts-revival Jewel/Osco market in the 1990s, a last photograph of this jail, prior to demolition, was captured for posterity. (Paddock.)

This late-nineteenth-century brick structure, shown here in 1962 at the tracks just east of the current location of Jewel/Osco on Western Avenue, was the busy Freight House, presumably designed by Charles S. Frost. Nearby was a spur for a siding and for access to the Lake Forest lumberyard. (Chicago Historical Society ICHi–24077.)

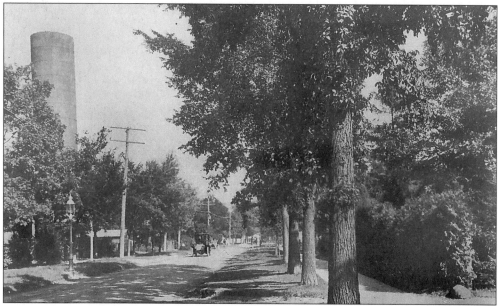

After an 1882 fire in the wood-frame business district, improved fire protection included water pressure, supplied by a new water tower, built in 1889 and shown here on the right, west of city hall. This view of West Deerpath shows this longtime local landmark, which was torn down in 1945. (Paddock.)

In 1900, the community's second African-American congregation was formed, in addition to the post-Civil-War A.M.E. church. This congregation was apparently drawn from a west-of-the-tracks population, a significant share of which, according to Griffith-firm records, was located around the southwest corner of Illinois Road and Bank Lane, today the site of the 1920s Deerpath Inn. The church edifice on Oakwood, celebrating its centennial in 2000, apparently had formerly been a Forester's lodge, according to fire insurance maps. (Paddock.)

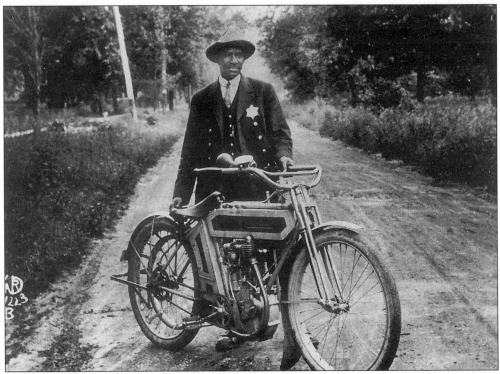

Walker Sales (1865–1919) is pictured here, in his role as the town's second policeman, on a striking motorcycle of the day. According to the historical society's 1994 book on the cemetery (67), Sales came to Lake Forest in 1890 from Kentucky, and was employed as a coachman for the I.P. Rumsey family, 404 East Deerpath. His spouse was America Bridgeman, a Fiske University graduate. (City.)

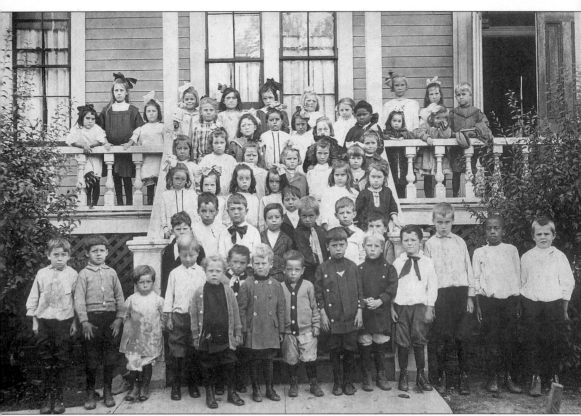

This apparently pre-World-War-I photograph of pupils on the steps of Lake Forest's South School on the northwest corner of Sheridan and Maplewood Roads, has been painstakingly identified. Bottom row, left to right, are: Raymond Baldwin, Fred Dornbush, Eddie Peddle, Edward Gansberg, Arthur Johnson, Joseph McGovern, Arnold Carlson, Patrick Baldwin, Edward Boobyer, Oliver Lindenmeyer, Henry Beebe, Alfred Marwede, William Lenore, and William Haltenhoff; second row: John Redmond, Richard Baldwin, Arthur Baker, Eddie Whalen, Frank Jaeger, Joseph Peddle, Christie Peterson, and Leonard Burns; third row: Helen Peddle, Madeline Baldwin, Anne Mae and Sarah Jane McGovern, Doreen Hiscox, and Sadie Sage; fourth row: Emily Bowman, Margaret Baldwin, Kathleen Ryan, Beth Jackson, Rebecca Preston, Madeline Ryan, and Mary Peddle; fifth row: Rose Gansberg, Margaret Preston, Agnes Whalen, Mary Baldwin, and Fannie Rodgers; back row: Frieda Lindhal, Mary Baldwin, Ruth Heaney, Mary Kent, Helen Walker, Elizabeth Haltenhoff, Mary Cavenaugh; Katherine Lindenmeyer, Anna Cavenaugh, James Crane, Ellen Baldwin, and Eleanor Haltenhoff. (Peterson/Paddock.)

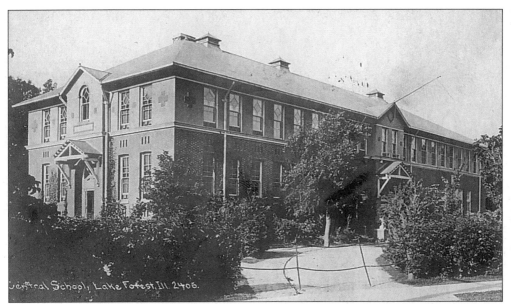

A new central public school was built on Illinois Road just east of McKinley in 1896, designed by James Gamble Rogers and remodeled and later expanded by Howard Shaw. After 1904 and into the 1940s, the superintendent was John E. Baggett, who had previously served in the Waukegan schools. Baggett toured Europe during the summers and brought back art work to display. This entrance facade, mostly preserved until a 2000 renovation, became the Gorton Community Center in 1972, an early local preservation effort led by Brooks and Jackie Smith. (Paddock.)

Here Baggett is shown leading an art class for Gorton School's pre-high-school pupils. In this classroom, students are surrounded by classic works of art. In this way, the young people growing up on estates or with parents engaged on or serving them gained an appreciation for classic taste, one result being that some records of these places in town only survive locally apparently through support family respectful stewardship. This special Arts & Crafts-rooted local bond between the employee and her/his life's work provides a distinctive character to the local community heritage. (Lake Forest/Lake Bluff Historical Society.)

The first Church of St. Marys was constructed in 1875. In the 1890s a parish house (demolished) shown on the left, was designed by a Chicago architect named La Pointe, according to Harold T. Wolff. This serenely-dignified 1909 red-brick second Church of St. Marys, standing today on the southeast corner of Illinois and Green Bay Roads, was designed by pioneer church architect and Chicagoan Henry Lord Gay. The Gothic-shaped church has many classic features typical of Renaissance churches; its stately exterior remains one of the anchors of estate-era Lake Forest. (Paddock.)

The Horticultural Society's pride and solidarity (see p. 6) were displayed in its floats in the annual early August Lake Forest Day, still a local midweek midsummer holiday. The group's float pictured here passes near the Northwestern station on Western Avenue. (Paddock.)

Six

MARKET SQUARE

As the post-1893-Exposition City Beautiful Movement resulted in the Chicago Plan of Burnham and Bennett in 1909, local thoughts turned to the untidy jumble of commercial establishments now sandwiched between estate areas. In 1912, a group of local estate owners formed the Lake Forest Improvement Trust, which created the first-ever town center developed around the automobile. Urban historians Michael Ebner (*Creating Chicago's North Shore*. U. of Chicago Press, 1988) and Richard Longstreth (*From Central City to Regional Mall*. M.I.T. Press, 1997) both have discussed this phenomenon, adding to the information in Susan Dart's very useful 1984 book, *Market Square*. However, a few additional observations remain to be made.

Certainly one major addition comes from the uncovering by Shirley Paddock of the planning files for the building of the Square, long stored in the basement of the Griffith, Grant, and Lackie real estate office, the only original Square tenant still in the same location. The long-undisturbed files, now donated to the Archives of the Lake Forest College library, detail this process in 2,000 communications, and over 50 blueprints and drawings. The idea is seen not just springing full-blown from architect Shaw's head, but rather evolving through a five-year process drawing in many stakeholders. The built plan is the third major scheme proposed, drawing much on English Arts & Crafts thinking and precedents, along with Beaux-Arts planning principles. The Square's survival and robust health today speaks to the wisdom of the concept, one worth returning to as the type has moved on to bigger and less inspired versions elsewhere.

The people of the Square, through their continuity and evolution, have defined the unique local character. Letters depict significant Chicago developer Arthur Aldis intimately involved and deeply caring, along with Chicago contractor James O. Heyworth, who worked hand-in-glove with Shaw and his team to implement the architect's vision. Other leading characters included Shaw associate Robert Work, engineer/architect Sutton Van Pelt, the on-site construction manager, and John Griffith, the local developer who made this beautification idea a commercially viable venture, a key element in its being copied elsewhere.

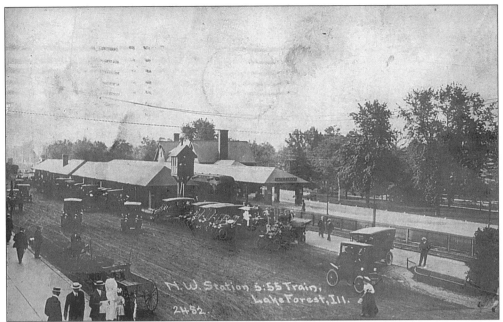

This bustling scene is the arrival of the 3:55 train in summer, with passengers being met, still in time for late-afternoon activities. A little dialogue, "Country Life," in Janet Ayer Fairbanks' *In Town* (1910) begins: "I'm delighted you've been able to catch an early train!" The 1900 station became a gathering point, but the untidy business district was an eyesore. In 1912, architect Howard Shaw and a group of local estate owners formed the Lake Forest Improvement Trust to remedy the situation. (Coll.)

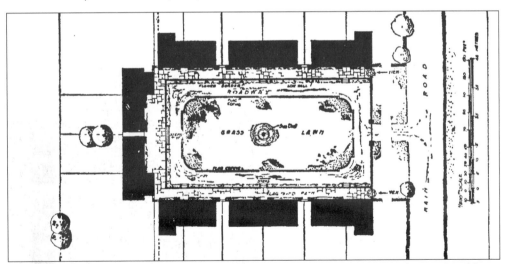

Shaw traveled abroad again after his early 1890s studies—in 1900, 1908, and 1913. His library at Ragdale also reflected his knowledge of British architectural and related ideas—Reginald Blomfield, *The Formal Garden in England* (1892) and Gertrude Jekyll, *Garden Ornament* (1918), for example. Raymond Unwin's 1909 *Town Planning In Practice*, published in London, included examples of traditional and newly-developed British communities. This book, contemporary with Shaw's stays in Britain, includes plans suggestive of the final layout of Market Square, such as this one. (Coll./TG.)

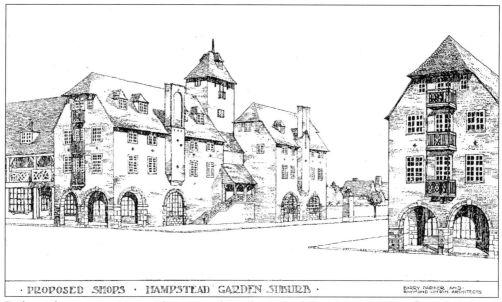

Early in the century, Unwin's Henpstead Garden Suburb had been developed on the edge of London, a planned Arts & Crafts community with two towers at the entrance to the development. Here it is pictured in Unwin's 1909 book, frequently reissued. The east end of Shaw's final plan for Market Square, with its two towers, resembles this high-profile London project and its German town antecedents. (Coll./TG.)

But such Arts & Crafts towers were not new to Americans, the Shingle Style of the 1870s and 1880s having employed such Old World motifs. Well-known in Lake Forest is the 1887 Cobb & Frost Presbyterian Church tower (p. 41). Also, the Newport Casino of the 1870s by architects McKim Meade and White is built around a central open space, in this case a grass tennis court, with shops on the street outside, another story above, and this clock tower facing the interior lawn (tennis court). (Miller.)

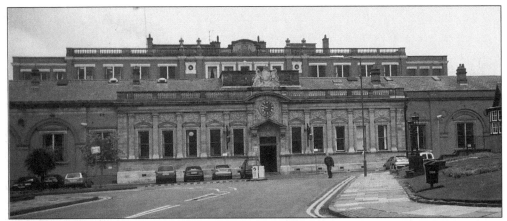

A 1916 Chicago newspaper clipping, which turned up in the Griffith, Grant, & Lackie archive, mentions Liverpool, England's Port Sunlight planned town for Lord Lever's employees, developed beginning in the 1880s. After contacting Port Sunlight historians, Shirley Paddock and her husband, Harold, visited there in the spring of 2000. The entrance to the Lever factory employs the classical Georgian vocabulary which Shaw drew upon for his main central building, now Marshall Field & Company's Lake Forest store. (Paddock.)

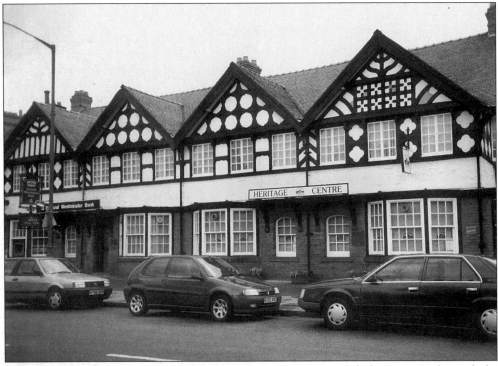

This view of a residential section of Port Sunlight reflects the English domestic Gothic style for cottages, seen in Market Square along the sides of the Square. Port Sunlight is just one of many such garden suburbs planned in Britain, some of them outlined in Unwin's book and other volumes—for example, Bourneville. In America, such model towns sprang up, as well—Garden City, New York, and Radford, New Jersey, etc. (Paddock.)

The shape and elements, if not the scale, of this mall in Port Sunlight, seen here, bear a strong resemblance to the central park in Market Square—the water feature at the end, the open greensward, the double row of trees defining the edges, etc. (Paddock.)

In 1915, Shaw was developing the large-scaled William V. Kelley estate on North Green Bay Road, just beyond Lake Forest in Lake Bluff—north of Ragdale (today Harrison House Conference Center). This tower forms part of the barn auxiliary complex northeast of the house. Its height and relation to the building is similar to that of the south and north buildings of Market Square, being planned in the Shaw office at about the same time. (Paddock.)

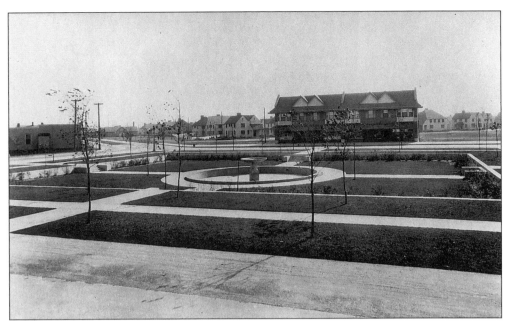

Shaw himself also developed a model town for Lake Forest resident Clayton Mark at Mark's steel mill in East Chicago, Indiana (1917), a construction picture and plan of which can be found in Virginia A. Greene's 1999 *The Architecture of Howard Van Doren Shaw* (129). This contemporary view of the only partially-realized Marktown plan shows the Market Square scaled shops facing a square with a sunken garden with a fountain, very classic. (Marktown/Myers.)

In the background of Marktown's central square is the neighborhood of homes for the workers at Mark's steel mill. This view in the historic district shows one of the restored semi-detached English Arts & Crafts cottages and its lawn. Note the arrangement that places houses against the street to stagger the dwelling units for privacy and to leave open space. Also, the duplex's double-gabled roof line on the street recalls the facade of Shaw's own Ragdale (p. 122). (Paul Myers.)

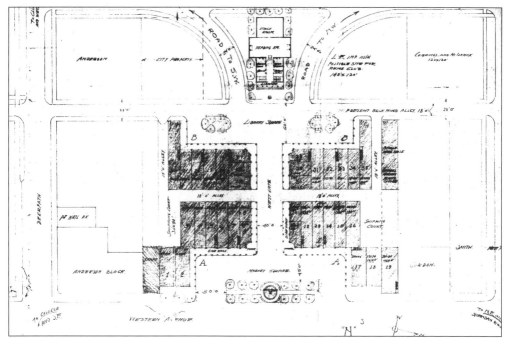

This is the second, or 1914, plan of three main proposals done for the Market Square space between 1912 and 1915. The first, Town Market, is referenced in Ebner's 1988 book—the plan from the Griffith basement archives shows a lack of focus. This 1914 plan has two poles, the train station facing lateral or shallow park and the west-end library. (Griffith/Coll./TG.)

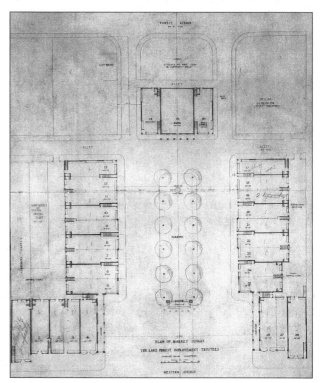

Urban historian Richard Longstreth, writing in 1997, points out the genius of this final plan of late 1915, with its long or deep mall facing the station, "...it tripled the amount of prime retail frontage. All the stores can be seen by the detraining public, in one sweeping view!" The original Square as shown here was left quite unimproved and simple, leaving clear vistas to each store window. The full development of the space as a park wasn't completed until 2000. (Griffith/Coll.)

Susan Dart's still-essential and still-in-print 1984 book, *Market Square*, published by the Lake Forest/Lake Bluff Historical Society, explains the process of incorporating two of the former Western Avenue buildings into the complex, one facing Bank Lane and still labeled "1894 Speidel" for the original commercial family, and one in the alley, for the complex's heating plant. (Paddock.)

The Improvement Trust's Market Square fit into a precisely-defined location, bounded by the train station and Western Avenue, the Griffith Block on the north on Western, and the Anderson Block on the south on Western, with the fire station (Frost & Granger, 1900) on the southwest, shown here—all with English historical style and all but the Anderson block traditional or Arts & Crafts. Since the 1980s, the fire station has been the Southgate Cafe. (Coll.)

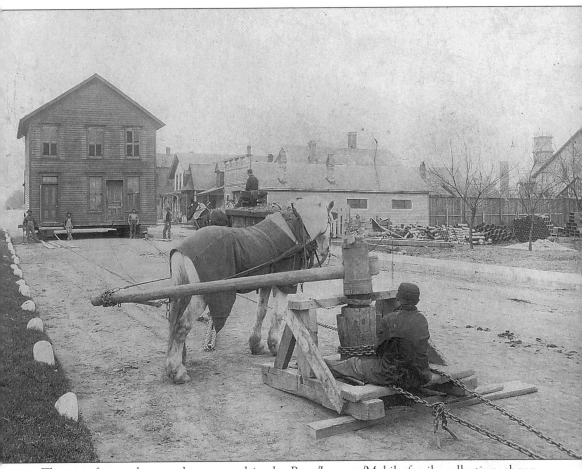

This significant photograph, preserved in the Rose/Lanners/Mobile family collection, shows one of the stores on Western Avenue near the station being moved north along Western, just beyond the Westminster intersection. Immediately to the left of the building being moved is a glimpse of the gray wood-frame building which stood on that corner until 1998, the last of the original structures left in that block of Western. Also, on the far right is the 1862 former Presbyterian Church, probably designed by Asher Carter but with a tower added later (according to a newspaper photo in the church archives). On the site of O'Neills for most of the twentieth century, it was moved there in 1886, as partial payment to Church contractor Patrick Haley (or Healy) for construction of the barn at the Manse, 487 East Walnut (p. 41), according to Church records found by Jennette Mattoon. See also the Chicago *Record-Herald*, December 10, 1911. (Mobile.)

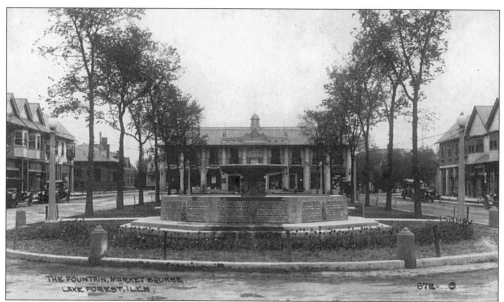

But once it was complete, Market Square was something new—one unified, but not overbearingly repetitious, whole, conveying both informality and order. The style, which incorporates both classic and domestic-Gothic motifs, echoes the Arts & Crafts town planning of Britain of that day. It was fitted in among several projects, which provided the architectural context: city hall (1899) and the fire station (Southgate, 1900, shown here left of Marshall Fields today), southwest; the train station (1900), east; the Anderson Block (1903), south; and the Griffith Block (1904), north. All were English traditional style, except for the Anderson block, which was Georgian. (Dart/Coll.)

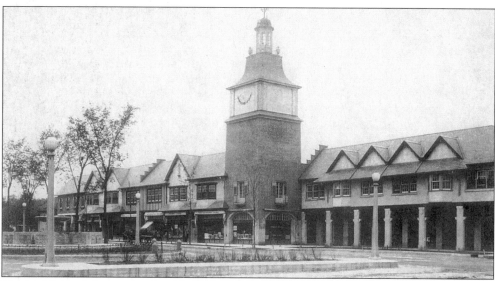

The highlight of the north side of the Square is the taller of the two towers, this time classically styled with a sun dial. Rooted in Georgian classicism, it may owe something to R. Ostberg's similarly massed and simplified Stockholm Town Hall of 1911–13, as seen in Banister Fletcher's *History of Architecture*. (1948 ed., pp. 601 and 868.) This arcaded block balances that to the south, but has its own distinct character. (Paddock.)

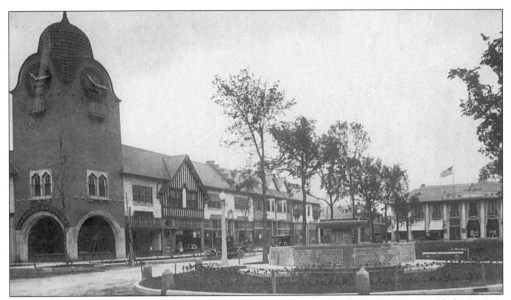

The informal north and south buildings employ a charming and contrasting, English Arts & Crafts vocabulary, drawing on traditional motifs from Germany's Romantic Road (which Shaw visited) to manors and villages of backroads southern England. Closest to the train station and its strong English traditional spirit, the two buildings north and south acknowledge this informal character. The south clock tower has a charmingly romantic, German-inspired, curving dome. (Dart/Coll.)

According to the list of Shaw's extant work in Susan Dart's 1991 *Supplement* to Arpee (340), Shaw designed the English-Gothic Methodist Episcopal Church in 1923 at 350 East Deerpath, on the northeast corner with MacKinley. Beyond the scope of this study's time frame, which ends around 1917, the date of the entry of the U.S. in World War I, this still shows Shaw, close to the end of his life, extending the spirit of the Square across the tracks to the east—a precedent apparently not followed by all later builders along that block. (Paddock.)

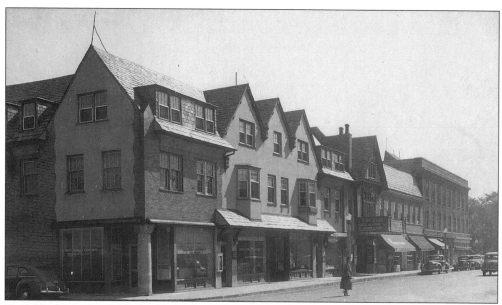

One block south of Market Square, on Deerpath, this former Deerpath Theater Building, designed in the 1920s by architect Stanley Anderson (1896–1960), echoes the English traditional style of the Square just to the north and also the city hall building a block west. Educated at Lake Forest College (Class of 1916), the U. of Illinois architecture school, and L'école des Beaux Arts, Paris (1919), Anderson joined Shaw's firm as an associate. He began his own practice in 1923 and, like Shaw, drew on family-related commissions to launch his career, developing the whole block west of the Rogers building for his family's trust. (Paddock.)

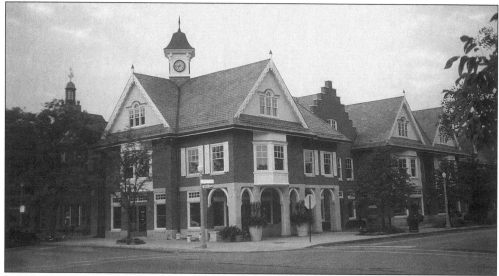

In the 1990s, the new Lake Forest Bank developed the south side of Westminster, one block north of Market Square between Western and Bank Lane in two phases, also in the English traditional style of Market Square, with contextual roots going back to city hall (1899). This 1990s extension of the central district—more formal on the east and less so on the west, as on Deerpath—continues a process begun over a century ago and spanning many sensitive architects and clients, with its focal point being Shaw's Market Square of 1916–17. (Paddock.)

Seven

GREAT ESTATE
LIFE CYCLES
THREE STORIES

Three exemplary tales outline the history of great estates formed before World War I. The chronicle of more than a century of the 1872 Simon Reid estate, the Lilacs, recounts a long relationship with a neighboring institution, Lake Forest College. The property which began as a lakefront hotel and then housed Lake Forest College became a private estate, Blair Lodge. This important, but forgotten, estate (the house was torn down before World War I) was subdivided early in the century and again in the 1990s. However, substantial architectural remnants of the two pre-World-War-I estates survive, though most of the landscape is lost. Finally, architect Howard Shaw's 1890s Ragdale remained in the family until the 1980s, evolving from an informal artists' colony into a more formal one in the last third of the twentieth century, with the Ragdale Foundation residency program. This architecturally and historically significant estate is preserved much in tact, in this case through a partnership of the City of Lake Forest, Lake Forest Open Lands, the family, and the new Foundation.

At the beginning of the twenty-first century, the remnants of estate-era Lake Forest give the Lake Forest of today a unique character in the Chicago area. Virtually alone among lakefront suburbs, the landscape dimension of the estate heritage is preserved here, and gardens and restored natural features remain the focal points of the community—on the east side, set among ravines in Almerin Hotchkiss's remarkable anti-urban plan and further west, developed around striking estate-era features such as the Lasker and MacIlvaine estates, Mellody Farms, and the stables at Elawa Farm on North Waukegan Road.

Lake Forest, built and preserved over multiple generations, is the work of many persons, both longtime residents and new arrivals, and also organizations. But a retrospective view like this owes the most to longtime residents who have preserved the images and stories—prerequisites to saving the houses, outbuildings, gardens, bridges, natural features, and, in a larger view, the local character. The builders of all walks of life and their personal accounts are the true foundations of Lake Forest's uniqueness.

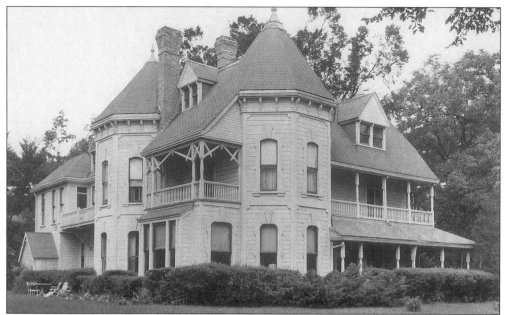

Harold T. Wolff helped determine that pioneer Chicago architect Rufus Rose designed this 1872 Stick style and Italianate, Eastlake-inspired wood-frame country place for Scottish-born Simon S. Reid and his Buffalo-raised spouse, Martha (McWilliams) Reid, Lake Forest residents after 1869. The house, on the southwest corner of today's Sheridan and College Roads (since 1971 once again open space), faced south on its garden facade over a large meadow opposite the then still vacant College Middle Campus. (Coll.)

This interior view of the Lilacs, taken in the mid-1960s, shows its last private mistress, Mrs. Rinaker, in the hall. This space may have been remodeled after 1872, since the Arts & Crafts inglenook and colonial-revival stairway would have been more typical a generation later. By then the Arts & Crafts Movement became established in Chicago, and the 1876 and 1893 Expositions, in Philadelphia and Chicago respectively, created the vogue for colonial-revival style. But the essential hearth-dominated domesticity of the entry would have been a continuing feature. (Coll.)

Simon Somerville Reid (1829–1892) founded the wholesale grocery firm that became Reid Murdoch and Company in 1865. Early 1850s Buffalo directories list Reid as a bookbinder, and the only McWilliams in town was a shoemaker. Entering the grocery business and then going to Dubuque on the Mississippi River, the young firm soon moved to post-war Chicago at the outset of the rail-driven expansion. (Coll.)

In this period, unlike at the east-coast resort Newport, life centered on church, schools, and home-life. This copied dagguereotype image depicts Martha McWilliams Reid prior to her move to Lake Forest. Of the Reids' four children—son Arthur and daughters Alice, Lily, and Grace—only two survived. Alice married Chicago reformer Clifford Barnes, settling at home, and Grace married and then lived elsewhere. (Coll.)

This somber image depicts Martha McWilliams Reid placing a time capsule containing memorabilia of the deceased children and of the occasion (listed in an issue of the College's *Stentor* of early November 1899) in the cornerstone of the College's Lily Reid Holt Memorial Chapel. Mrs. Reid gave the Frost & Granger-designed chapel and Arthur Somerville Reid Memorial Library (today Reid Hall) complex (1899–1900). Both deceased young people had been Lake Forest College students. (Barnes/Coll.)

These Reid memorials still stand, their exteriors restored in 1998–99. Handsome Collegiate Gothic structures of the best gray Bedford (Indiana) limestone, they set a new standard of quality for the College, which had succeeded the earlier university model. The materials and style reflected that of Cobb's 1893 plan for the University of Chicago, but the layouts of the buildings were derived from forms typical of H.H. Richardson, as established by architectural historian Kingston Heath (Lake Forest College '68), in whose office Granger had begun his career. (Paddock.)

Continuity of the Reid family and fortune fell to the remaining daughters. Alice's husband, Clifford Barnes, was a leading Chicago reformer educated at Yale (Class of 1888), who came to Harper's Chicago in the early 1890s and soon met Jane Addams. After his marriage, Clifford was president of Illinois College, founder of the Chicago Community Trust (1915), and a crusader for women's voting and other rights. (Chicago Historical Society ICHi–18748.)

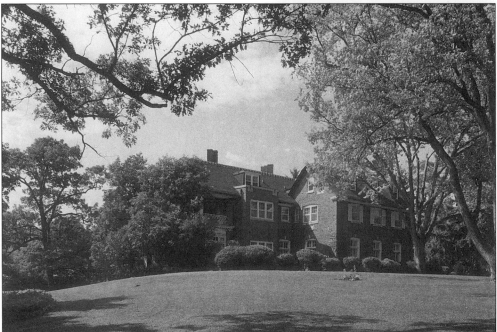

Barnes commissioned architect Howard Shaw (Yale Class of 1890) to build a new house for the estate in 1908, situated southwest of the Lilacs. This pressed-brick English traditional-style house echoes Frost & Granger motifs and materials from the library, chapel, and residence hall across Sheridan. The photograph from 1980 is by Richard Smith. (Coll.)

The formal gallery of Glen Rowan's first floor central hall Beaux-Arts plan, shown here as furnished in the Barnes era, was a favorite Shaw feature also used at Shaw's own Ragdale, but there laterally. Here the informal exterior masks the interior classic order. The stairway is on the right. (Barnes/Coll.)

Southwest of the house, to be viewed from the porch and the dining room, was the stunning Arts & Crafts garden, which extended to the ravine edge. The tall house from this side ended on the south with porches on two floors, with the master sleeping porch on the second level. (Barnes/Coll.)

The flower and kitchen gardens were shaped like those at Washington's Mount Vernon, but joined by a short pergola, which survived until 1999. This interesting colonial-revival feature added to the eclectic, Arts & Crafts character of the estate. The garden was staffed often by students from the college, one of the perks being dinner in the basement servants' dining room, which outshined the 1930s student fare across the road where Barnes was a trustee. (Barnes/Coll.)

Here Clifford's daughter, Lilace, hosts a Glen Rowan terrace wedding reception after Clifford's death in 1944. It had been after the 1918 death of Webster, Clifford and Alice's son, that Lilace had become heir apparent to her father's reform agenda. She later served as international president of the YWCA and championed open housing, hosting a gathering attended by Dr. M.L. King Jr. at her home in the mid-1960s. Both were trustees of the college, Lilace being the first woman in 1944. (Coll.)

By the late 1960s, Miss Barnes sold the properties to the college on favorable terms and moved into a new modern-styled house, designed by Balfour Lanza, in the ravine south of Glen Rowan and near the garden, which was renovated into a simpler design by Gertrude Kuh after Lilace moved. (Barnes/Coll.)

Lilace Barnes continued to pursue her interests from her new base, the third house on the estate for the third generation. Her interests included the local Presbyterian Church and welcoming new faculty families, often around the circular Mission-style table brought with her from Glen Rowan. Shown here is a 1978 Halloween scene with an elderly Miss Barnes visited by two Miller children trick-or-treaters, Janelle (right) and Andrew. (Miller.)

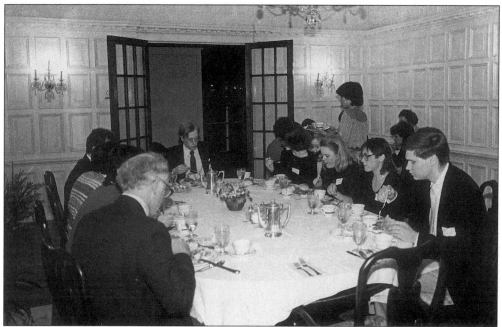

The college initially leased the house c. 1970 to the First National Bank of Chicago (successor Bank One), which undertook a seven-figure sensitive renovation to accommodate an adaptive reuse as a conference center. A decade later, the college redecorated the house for its own use. The formal dining room, with its Arts & Crafts Shaw-designed plaster friezes, was the setting for a series of sophomore student suppers in the 1980s, one of which is pictured here. (Coll.)

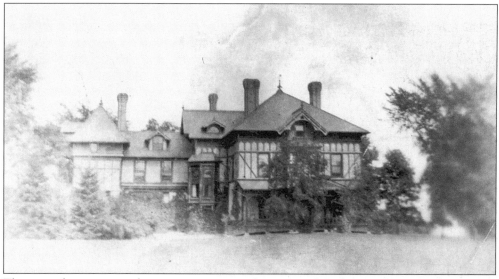

The second estate story here traces a reversed pattern of evolution, from commercial and institutional to private estate, with subsequent subdivisions. The New Hotel of 1871, briefly a Lake Forest University building, had burned in 1877. In 1880, the W.C. Larneds (Mrs. Larned a daughter of New York publisher Charles Scribner and granddaughter of railroad baron John Insley Blair) apparently commissioned William LeBaron Jenney to build them a new lakefront estate, Blair Lodge, pictured here c. 1905 by landscape architect John C. Olmsted. (Paddock.)

Jenney designed the West Side parks in Chicago in 1870–71. The rustic gateway south of Blair Lodge, in the rural landscape tradition, led to a curving entrance drive. This photo, apparently by landscape architect John C. Olmsted about 1905, shows the southern portion of the Blair Lodge property, bought by Chicago banker Ernest A. Hamill. Olmsted's illustrated correspondence in the Library of Congress shows this existing drive incorporated into the plan for the Hamill estate. (Paddock.)

The large Tudor house, Ballyatwood, was designed by Spencer & Powers, a Chicago firm with Prairie School associations. Still standing at 433 North Mayflower, it was reduced and substantially renovated by architects George Brewster and Harry Weese. According to David Adler historian Steven Salny a redesign by Adler never was implemented. Today the horse remains, remaining a credit to the Olmsted firm's siting and the Hamills' and Spencer & Powers' sturdy construction. (Paddock.)

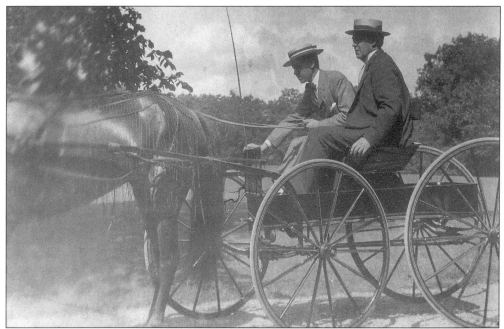

Seated in this early 1900s buggy are Ernest A. Hamill and his son Alfred E. Hamill (1883–1953). Investment banker Alfred Hamill later had his cousin Henry Dangler design his 1913 house at 1115 East Illinois at Mayflower, the Centaurs, which was expanded and renovated in 1928 by David Adler, the late Dangler's partner. Alfred was president of the library board when the 1931 Lake Forest Library on East Deerpath was built. (Paddock.)

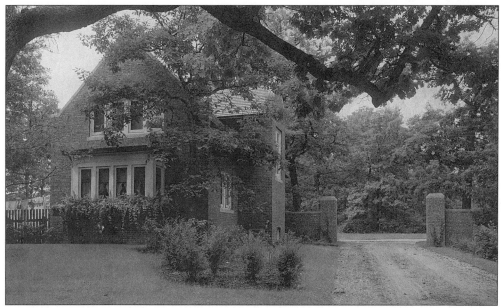

The Spencer & Powers gatehouse, pictured here in its original state, is little changed today, though the brick exterior is painted. It manages to reflect both Tudor traditional style and Prairie School simplicity. Recently subdivided off and protected by a facade easement, it is owned by David Bahlman, executive director of the Landmarks Preservation Council of Illinois (LPCI). (Paddock.)

In 1913, landscape architect Jens Jensen was engaged by the Ernest Hamill family, according to Robert Grese's *Jens Jensen . . .* (Johns Hopkins, 1994). This view of the Hamill ravine reflects development in the Prairie Style, consistent with Jensen's appreciation for natural features. Jensen's efforts to restore and include elements such as ravines and lake bluffs in estate layouts can also be seen at Highland Park's A.G. Becker estate, recently restored by landscape architect Steven Cristy. (Paddock.)

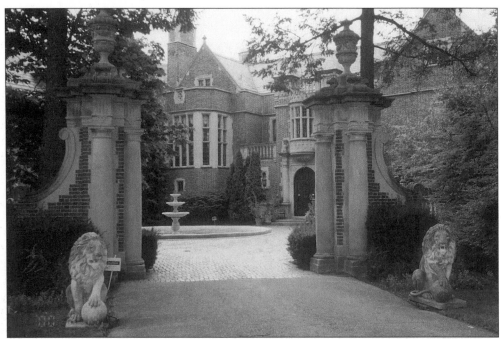

Today known as Mayflower Park, this 24,000-square-foot Tudor house replacing Blair Lodge in the center of that property was designed by Chicago and Boston architect Frederick Wainwright Perkins. It was built in 1915, as a gift from Marshal Field & Co. president John G. Shedd for his daughter, Laura—Mrs. Charles Schweppe, spouse of an investment banker. The terrace facing the lake and this courtyard were the creations of Pray, Hubbard, & Co., an eminent Boston landscape firm. (Paddock.)

The third and last estate profiled here is Ragdale, constructed in 1897–98 for the multi-generational Theodore Shaw/Howard Shaw family of the old Prairie Avenue neighborhood. This English Arts & Crafts house, at 1230 North Green Bay Road, is one of the early west-facing places north of Deerpath and the architectural inspiration of young Howard Shaw. Ragdale sparked a development of mostly Shaw-designed places on North Green Bay, not far from the new Onwentsia Club. (Miller.)

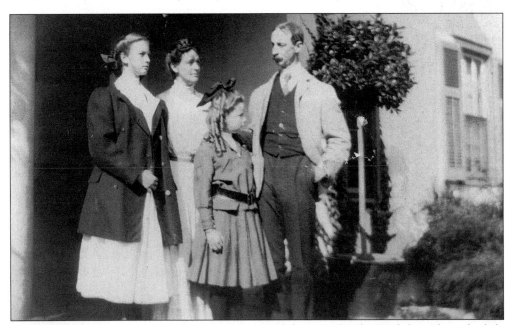

Architect Shaw poses here in front of his house with his own family. With him, from the left, are his older daughter, Evelyn (later Mrs. John T. McCutcheon); his spouse, the poet Frances Wells Shaw; and his second daughter, Sylvia (later the sculptor of Savannah's "Bird Girl" and "The Girl with Baby on Shoulder," in the Market Square fountain since 1982). A third daughter, Theodora, was born in 1912. (Hayes/Coll./TG.)

Pictured here late in life is Howard Van Doren Shaw (1879–1926), on a bench of his own design at Ragdale, with his grandsons by his oldest daughter, Evelyn Shaw McCutcheon, spouse of *Tribune* cartoonist and writer John T. McCutcheon. Shaw, who collaborated with great garden and landscape designers, interested himself in garden structures, furniture, and layouts—much like English architects of the period, Edwin Lutyens and Norman Baillie Scott. (Dart/Coll.)

Shaw was an honorary (male) member of the Garden Club of Illinois, which became the Lake Forest Garden Club after 1922. His Beaux-Arts central driveway for Ragdale ends in a forecourt circle, which was home early on for Hermon Atkins MacNeil's Native-American-honoring sculpture, "The Sun Vow," now in the Art Institute of Chicago. Seen here posing with this sculpture is Ragdale garden staff member Sylvester MacDonald, prior to 1930, when the Ragdale-trained plantsman took over the care of the Shaw-designed E.L. Baker estate grounds and greenhouse (see pp. 75–77). (Paddock.)

The Shaws' daughter, Sylvia Shaw Judson Haskins (1897–1978), represents the third generation of the Shaw family, with Evelyn Shaw McCutcheon and Theodora King, the siblings who succeeded their parents as stewards of Ragdale from the late 1930s to the late 1970s. Sculptor Sylvia's share of the estate centered on the southern third, with the main house. Evelyn's third, on the north with the Ragdale Ring outdoor theater site, soon included a colonial-revival house designed by Theo's spouse, John Lord King. The sundial and dovecote in the still-preserved garden were Howard Shaw's creations. (Hayes/Coll.)

The Barnhouse (1240 North Green Bay), seen here in 1938, but now owned by the city, incorporates the 1838 original Swanton family Greek-revival brick farmhouse, apparently Lake Forest's oldest building, along with Shaw's 1897 barn and carriage shed. These form three sides of a courtyard, with a dry stone wall on the fourth, south side. The Kings converted this to a residence, then sold it to the Preston family after World War II. In 1980, the Ragdale Foundation bought the property and reunited it with the house; in 1986, both properties were given to the city. While Lake Forest Open Lands assumed stewardship of the long view to the Skokie River from the house, the Ragdale Foundation and its artist-community program became the resident. With Alice Hayes and her family, the fourth and later generations owning the contents and the cabin west of the garden, this public/private partnership has preserved most of the estate. (Hayes/Coll.)

ACKNOWLEDGEMENTS

Certainly Lake Forest College's collections and files (listed in caption credits as Coll.), apparently going back to Halsey's day and now in the archives, provided a foundation for this project. These collections includes materials from the late James R. Getz and from the Barnes, Griffith, Holt, and Shaw families. The project and all the support it received, especially from 1997 to 2000, which resulted in the August 2000 publication of the College's history, *30 Miles North*, led directly to this effort. Other institutions, their personnel, and their member volunteers who also have been crucial to this effort and to which/whom sincere thanks are extended include the Chicago Historical Society (Keshia Whitehead), Historic Marktown District (East Chicago, Indiana; Paul A. Myers), Panhandle-Plains Historical Museum (Canyon, Texas; William Greene), the Lake County Museum (Diana Dretske), the Lake Forest/Lake Bluff Historical Society (esp. Janice Hack, Ann Pollack, Steve Rice, and Georgia West), the Lake Forest Garden Club, the City of Lake Forest (Marilyn Alaimo, Kaye Grabbe, Rosemary Haack, and Commander Robert Reidel), First Presbyterian Church (Millicent Kreischer, Jeanette Mattoon, Donald Spooner, and Sarah Wimmer), Lake Forest Academy, School District 67, Griffith Grant and Lackie Inc. (Gordon Lackie), and Wenban Funeral Home (James Iacubino).

Several individuals have generously made available photographs and information, the former *credited in short form with the captions, but with full names listed here.* These include: Stan Anderson Jr., the late Mrs. Melvin Archer, Elaine Marwede Barner, Dorothy Palmer Bills, Sonja Boutin, Anthony Cascarano, Arlene Mattson Chope, Betty Birks Cutler, Susan Dart, Edison Dick Jr., Michael Ebner, Willis Griffis, Jean McMasters Grost, Corwith Hamill, Alice Hayes, Lucia Heyworth, Ruth Jackson, Bruce Johnson, Esther O. Johnson, Victoria Parshall Julian (Mrs. John), Waldron Julian, Becky Keller, Katherine Kingery, William Marlatt, William Marwede, Madeline Lanners Mobile, Kevin and Jane Moravek, James Niemeyer, John Notz, Mary Oldberg, William O'Leary, Helen Butterfield O'Neill, Bruce Patton, the late Lester Peterson, Bruce Southworth, Elizabeth Thomson, David and Pam Waud, Betty Malmquist Weber, Carolyn Wells, Kay Kerrigan Weston, Monroe Winter, Harold T. Wolff, and Doris Cole Yankee.

Special thanks go to master photographer and Lake Forest resident Timothy Gallagher (TG) for scanning about one quarter of the images from too-large, too-small, too-fragile, and too-deteriorated sources (including glass lantern slides), well beyond the Arcadia parameters for submitted material. Without reconstructing source data, he patiently and knowledgeably translated the originals into electronic format, using Lake Forest College equipment (for access to which the authors also are indebted and grateful), thus making them available to a wide and future audience. Similarly, we are grateful to Arcadia editors in Chicago, Tom Rakness and Carrie Radabaugh, to technician Mike Spiegel, and to the Arcadia staff for their generous encouragement, flexibility, advice, and support.

The authors finally express their appreciation to their spouses, Harold Paddock and Janet Miller, and to their families for their aid, comfort, and flexibility.

Selective Bibliography and Key to Short References

Arpee, Edward. *Lake Forest, Illinois: History and Reminiscences, 1861–1961* (Lake Forest: Rotary Club, 1963).

Dart, Susan. *Market Square, Lake Forest, Illinois* (Lake Forest/Lake Bluff Historical Society, 1984).

———. *Supplement.* [to Arpee] (Lake Forest/Lake Bluff Historical Society, 1991).
Includes the most accurate and complete list available in print of extant Lake Forest works by architect Howard Shaw, pp. 340–341.

Ebner, Michael H. *Creating Chicago's North Shore: A Suburban History* (Chicago: U. of Chicago Press, 1988).
Substantial modern documented coverage for Lake Forest history to 1918—esp. pp. 68–77, 195–209, and 243–46—by a Lake Forest College Professor of History.

Greene, Virginia A. *The Architecture of Howard Van Doren Shaw* (Chicago Review Press, 1998).

Halsey, John J. *History of Lake County, Illinois* (Bates, 1912).

Hayes, Alice and Susan Moon. *Ragdale, A History and Guide* (Berkeley, CA: Open Books and the Ragdale Foundation, 1990).

Lake Forest, Art and History Edition (Chicago: American Communities Company, 1916).
Includes John J. Halsey, "Historical Sketch," pp. 103–37; Halsey was a professor at Lake Forest University/College from 1878 to 1919.

Lake Forest Cemetery, Lake Forest, Illinois (Lake Forest/Lake Bluff Historical Society, 1994).

Lake Forest Foundation for Historic Preservation. *A Preservation Guide to National Register Districts, Lake Forest, Illinois* (Lake Forest, 1991, rev. ed. 1994).

Schulze, Franz, Rosemary Cowler and Arthur H. Miller. *30 Miles North: The History of Lake Forest College, Its Town and its City of Chicago* (Lake Forest: distrib. U. of Chicago Press, 2000).
In most instances documentation for the early history, for the educational institutions in town, and for the college's local patron group is available here; consult index.

Walking Tour of Lake Forest (Lake Forest—Lake Bluff Historical Society, [1977]).

INDEX